take that
IN PRIVATE

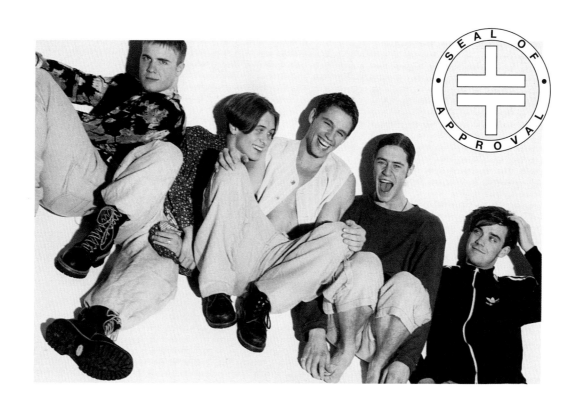

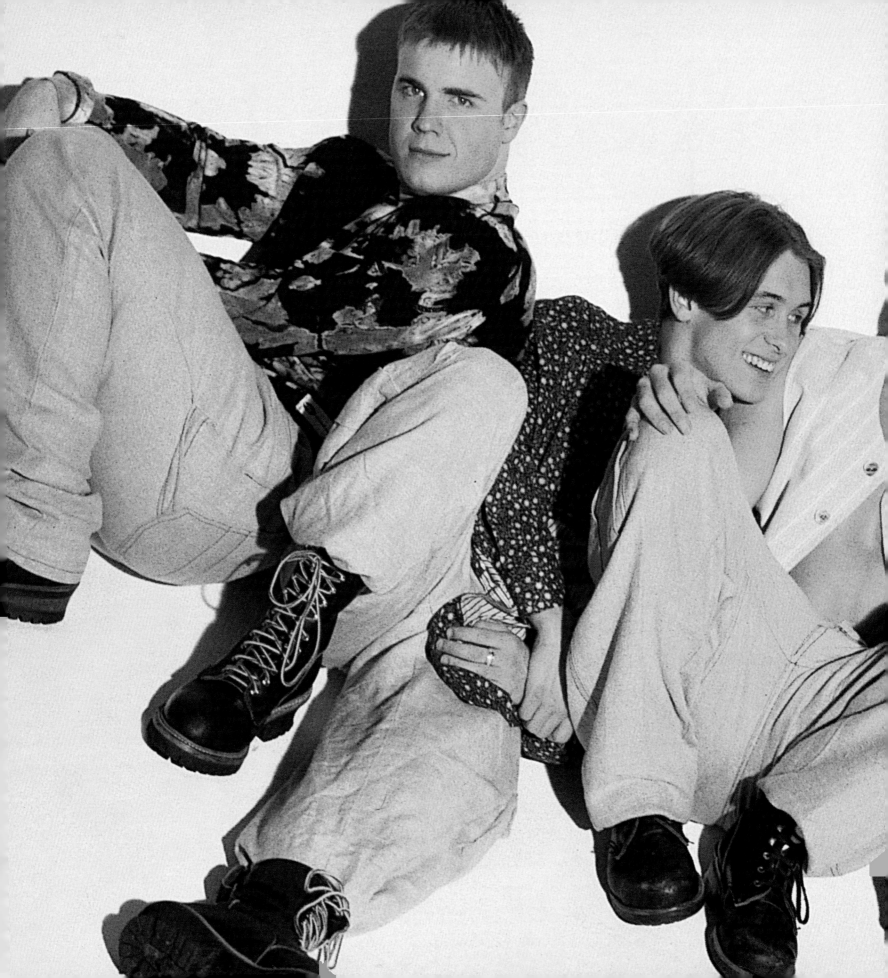

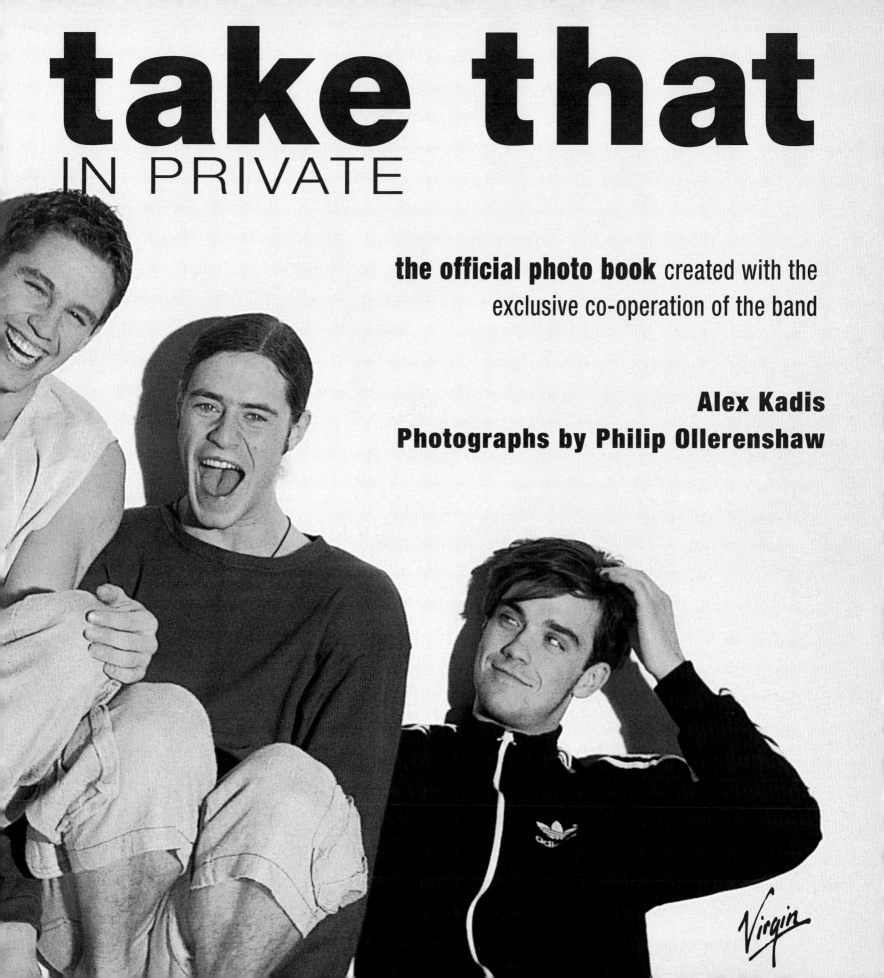

take that
IN PRIVATE

the official photo book created with the
exclusive co-operation of the band

Alex Kadis
Photographs by Philip Ollerenshaw

Virgin

First published in Great Britain in 1994
by Virgin Books
an imprint of Virgin Publishing Limited
332 Ladbroke Grove
London W10 5AH

Text © 1994 by Alex Kadis
Photography by Philip Ollerenshaw/Idols Licensing & Publicity Ltd. © Take That
© 1994 Licensed by Nice Man Merchandising (Europe) Ltd

A catalogue record for this book is available from the British Library

ISBN: 1 85227 530 8

Printed and bound in Great Britain by Bath Colour Books, Glasgow

Designed by Slatter~Anderson
For Virgin Publishing: Philip Dodd (Publisher), Carolyn Price (Project editor)
Editorial assistance from Anne Cree

To Our Fans

It was almost a year ago when we first had a meeting about this book. We decided we wanted something that would show our fans what it was really like to go on tour with us – something that was raw, uncut and above all revealing.

Philip Ollerenshaw was already travelling with us and had complete access on and off stage as our official photographer.

We had known Alex Kadis for years – she has been writing features on the band since the beginning and knows us inside out.

We knew we could trust them both to give you the real picture – and to buy us the occasional round in the pub! So they came on tour with us. Alex wrote down everything she saw and Philip snapped every time one of us moved.

The result is the book we've always wanted to do – honest, open and frank. There's stuff in here about us that we didn't even realize ourselves. Some of it made us laugh and some of it we found touching. The main thing is – this **is** Take That. We hope you enjoy reading it as much as we all enjoyed making it.

love Howard xx

love Gaz xx

love Robbie

love Mark!

Love, Jason xx

Take That's rise to superstardom is a well documented story. They took the UK by storm with their Everything Changes tour and ended the year in a true blaze of glory with a number one hit and a sweep of the board at pop's most prestigious award ceremony, The Smash Hits Poll Winners Party, after which they crept home to Manchester too exhausted, even, to attend the after-show bash. **British pop stars had never looked so rough but British pop had never looked so good!**

But there was a rumour: The British media thought the group were a phenomenon there and nowhere else. But, in fact, across the channel it was another story. Teenagers were in the grip of a new craze – a craze in the shape of five chaps from Manchester.

Now it was time to prove the sceptics wrong and to fulfil the growing demands of the foreign public. It was time to take the show back on the road.

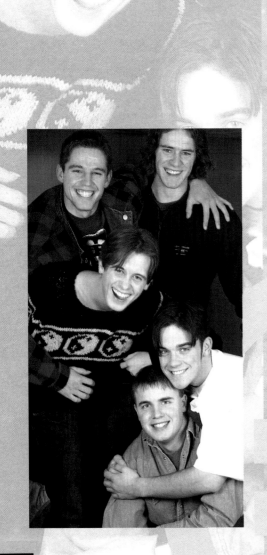

This book follows Take That not through the assured glories of a UK tour but through an arduous and career-testing journey in alien territories. The boys are far from home, weary and out to prove themselves all over again – in a place where they have only each other and the sure knowledge that they've done it once and **they can do it again.**

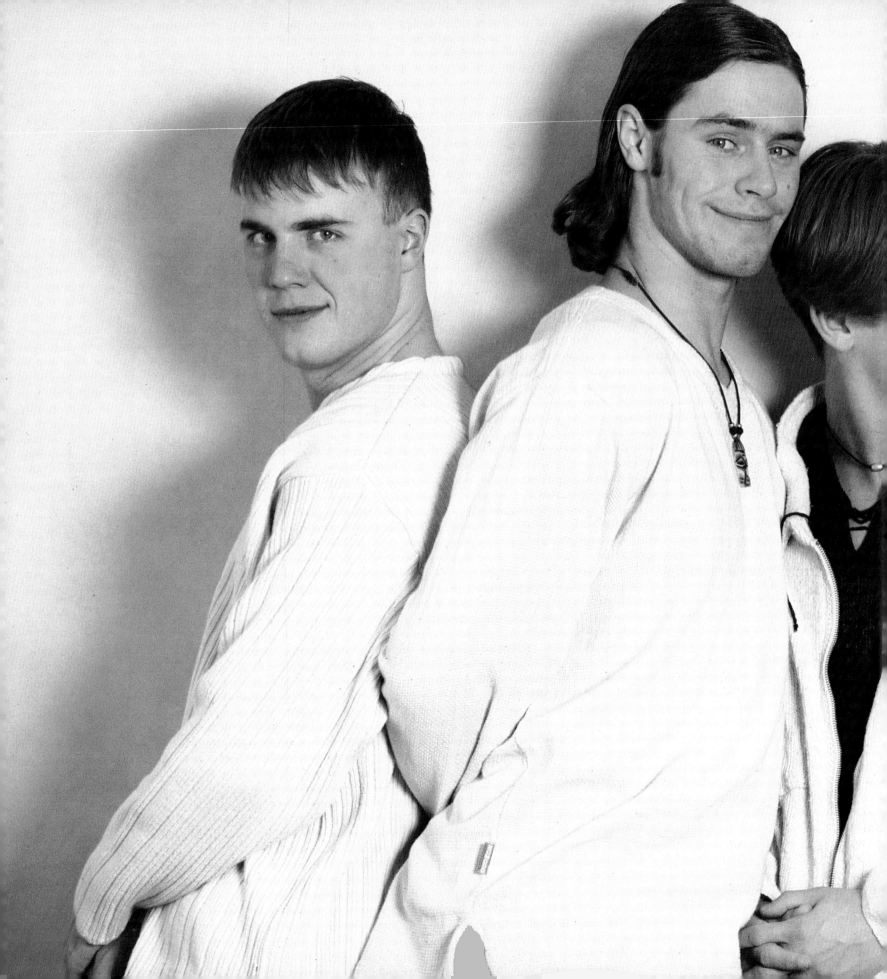

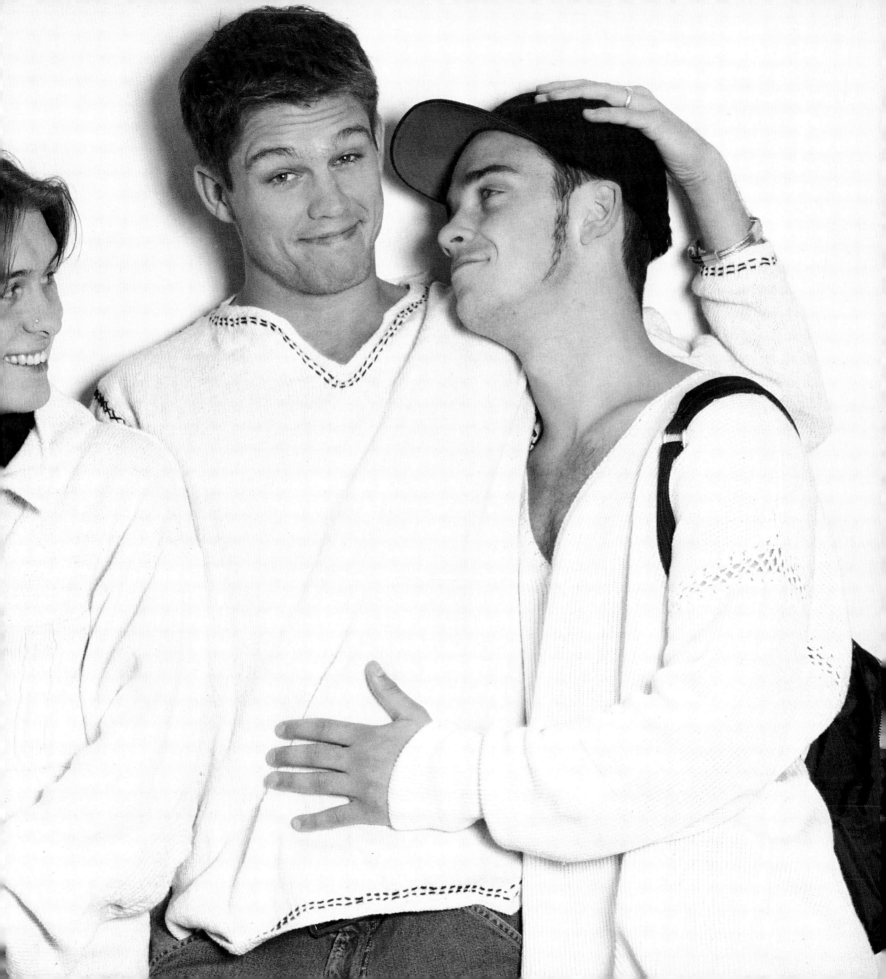

Germany has gone bonkers.

It is in the grip of Thatmania! Outside the Grand Hotel in Nuremberg, a mass of fans are clamouring at the doors. One flustered-looking doorman is attempting to hold them back. "I haven't seen anything like this in Germany since the Beatles!" he puffs. "Who are these teenyboppers, please?" Meanwhile, in the backstage corridors of the Nurnberg Frankenhalle a different kind of pandemonium is underway. Take That are relaxing before this, their tenth sell-out gig in the country. The venue staff are charmed. "We had the New Kids here once and they just sat in their dressing rooms sulking. **These guys are friendly. This is so... unusual"**

"**I haven't seen anything like this in Germany since the Beatles!**

Gary has roped Howard into a game of badminton.

'It's good this, innit?" He grins as he scores the match point and whacks the shuttlecock in Howard's face for good measure. "Who's next?" he asks triumphantly as he adjusts his impromptu "net" made from a piece of gaffer tape which stretches between the two walls. Jason meekly accepts a challenge.

"I've not played this before. I might not be very good. . ." he withers. "Go easy on me Gaz, remember my ankle." This isn't the first time that Jason has mentioned his ankle and it won't be the last. He has a bad sprain which has plagued him throughout the tour. Gary assures Jason he'll take this into consideration during the game and then proceeds to run his friend round the court scoring points rapidly. He throws his head back and laughs his machine-gun chuckle. But he has laughed too soon. . .

Meanwhile out back, in view of a few hundred screaming, pleading frauleins, Robbie and Mark play football with the crew. Robbie is drenched in sweat and covered in

dirt. "On me 'ead!" he shouts. "He shoots, he scores!!!" **"I've had enough of this. Show-off,"** says Mark, smiling, "I'm going to get changed."

Back inside, Gary is showing off. "You've got to be quick and agile. Like me!" His laughter trails off as Jason wins a point. By the time Jason has won the game Gary has ceased to laugh altogether but, ever the opportunist, he puts his arm around his pal's shoulders and says: "You know, I think we should become doubles partners. We could slaughter Howard and little Marky. What do you reckon?" Flushed with exertion, Rob sits on a step soaking up the wintery evening sun and sneaks a cigarette.

a little stir

' Does anyone

know about this

secret

plot to bring

my **mum**

over and

surprise me?

"Watch your backs everyone, Marge is coming!"

This is Gary Barlow. He's referring to his mum who is due to arrive tomorrow along with his dad. In her company will be Jason's mum Jenny and her best friend Gill, Rob's mum Jan and his sister Sally. It's all Robbie can think about: "I need my mum to talk some sense into me. She's bringing me homoeopathic medicines to get me to sleep and to give me energy. **I wish she was here now. I miss her.**"

Jason has his sock rolled down in anticipation.

"You wait, when mine sees this **she'll** be sympathetic."

Howard's mum is on holiday so she won't be coming but there is a secret plot to surprise Mark by bringing over his mum Mary and sister Tracey.

"Does anyone know about this secret plot to bring my mum over and surprise me?"he asks.

And so this is how we find Take That. Halfway through a ground-breaking European tour and perhaps a little stir crazy.

crazy

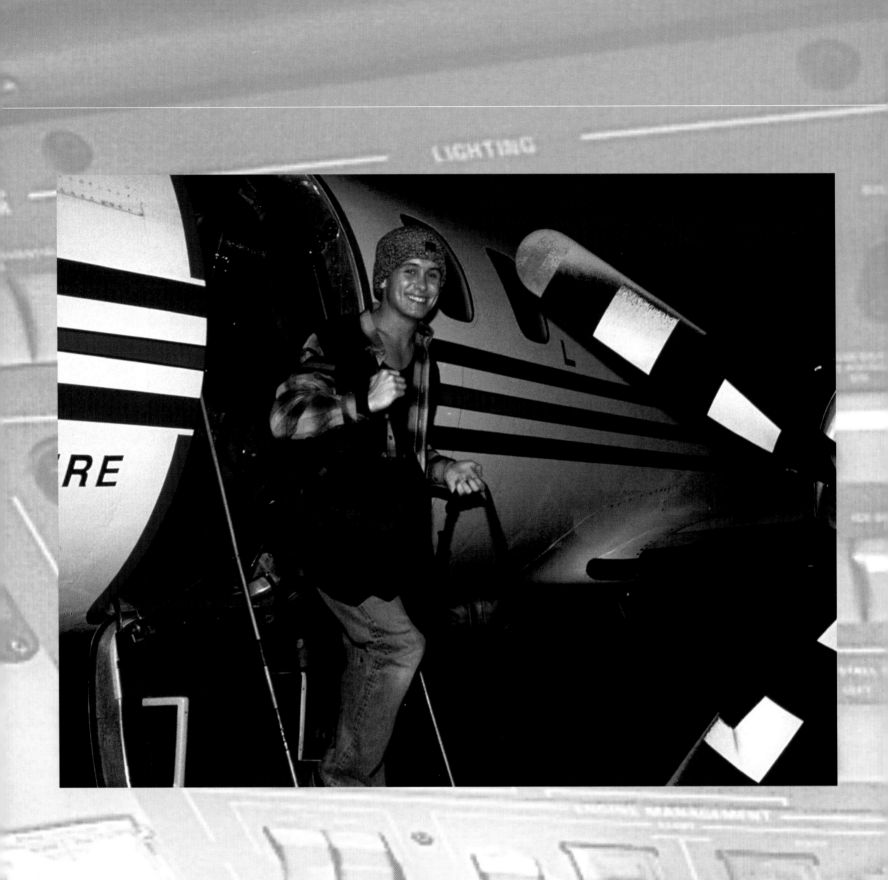

"**Hello, this is your Captain** speaking. We will be travelling at a height of approximately 36,000 feet and will be landing in Berlin at 300 miles per hour. We should be near enough to the sea so that the blood can be washed away. Can the passengers who are scared of flying please sit near me so that I can see the terror in their eyes. **Thank you.**"

"Captain" Gary Barlow is amusing himself no end at the expense of any other passengers who are terrified of travelling on the Take That private jet. The18-seater plane is the group's means of travel from country to country and is a new high in claustrophobia.

Jason is perhaps the worst flyer you'll ever encounter but he is immune, now, to Gary's tricks. He sits habitually at the front of the plane where no one can see him quake in his boots, Mark and Howard call themselves "plane partners", Gary sits with the musicians and talks studios while Rob usually lies on the floor!

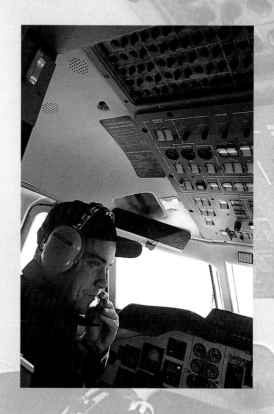

We've made up this **song** we all sing **every time we take off.**

It's called: "**We're going down with Glenn Miller**". It helps to **scare** anyone who isn't already scared of **flying!**

The Take That coach, complete with darkened windows, is waiting on the runway at

Berlin's private airfield. It is not, perhaps, as luxurious as you might expect. There are seats with tables downstairs, mostly favoured by Rob and Mark where they sit amidst Robbie's mess of empty cups, sandwich crusts and dirty clothes and play computer ice-hockey together.

Rob stares out of the coach window as we pass a park full of footballers playing in the fading sunlight. He stops play for a moment and sighs wistfully.

Rob: Mark, look. I want to be there. . .

Mark: Oh. . . we could try out our new boots. . .

Mark scores a point.

Rob: Oi. That's not fair.

He is distracted again by a girl who cycles by wearing a mini skirt, stockings and suspenders. "Blimey! Check that out!"

Mark scores a point.

Rob: Eh, that wasn't fair, I was laughing at that bird.

Mark: It was fair. I was laughing at that bird too.

Mark wins the game.

As we head towards East Berlin, the sun goes down and the prostitutes come out. Mark indulges in a bit of transvestite-spotting.

"There's this transvestite here who's after me. He – she – **it** keeps

hugging me to her bosom – it's like being suffocated!"

Upstairs on the coach there are bunk beds which are rarely used and a large semi-circular grey leather sofa where Howard, Gary and Jason relax and discuss "grown up" business.

Jason: So the rumour is we're all gay now are we?

Gary: Am I gay? I am? Why? Oh good. Just as long as I know.

Howard: Does anyone think I'm gay?

Jason: No, you're the only one people think is straight.

Howard is insulted.

Howard: Why aren't I gay? What's wrong with me?

Jason: It's because you're such a fine figure of macho manhood.

Howard: Well I want to be queer like you lot!

Mark comes up dolefully clutching a copy of *Just 17* magazine which has run a feature about an ex-girlfriend of his including excerpts of letters he wrote to her.

"How embarrassing," he cringes. "Oh well, at least I'm not gay for a little while."

TT assemble for their first interview of the evening backstage at the Berlin Deutschlandhalle with the *Manchester Evening News.*
Gary is munching on a bucket of popcorn which he is trying to wrestle away from Rob.
"Get your own," he grumbles.
The reporter from the *News* has just inadvertently insulted Rob.

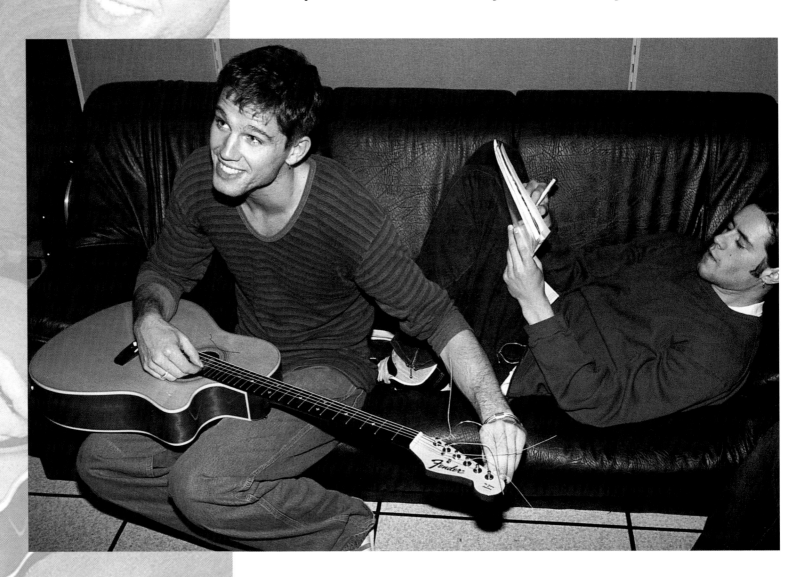

News bloke: Rob, have you had much time to follow your favourite football team, Stoke City?

Rob chokes on his mouthful of popcorn and jumps back in horror.

Rob: I support Port Vale, mate.

News bloke: How are you all bearing up on this tour?

Mark: Well we've all been ill. I got dehydrated by spending too much time in the sauna and was sick before the first gig. Now I feel like I'm getting a cold. We've all had minor things.

Jason says nothing, but rubs his backside moodily. He's just had a pain-killing jab for his leg and his newly injured arm.

News bloke: What sort of antics have you been up to?

Howard: We felt a bit rebellious the other night and cleared away the furniture in the hotel banqueting room for a game of football.

Rob: We broke the exit light and four ashtrays. We felt really bad afterwards and put all the furniture back and tried to hide the ashtrays.

News bloke: Are you recluses or can you still go out?

Gary: I go out. We all do. I went shopping in Cheshire with my mum the other week and I think she was scared at how many people recognized me. But if you don't go out you would lose it. I can understand why people become recluses. You have people to do everything for you – especially on tour.

Jason: It's a personal thing. You have to do things for yourself.

Jason rubs his backside and looks to his manager's assistant, Soozii. "Is my mum here yet?"

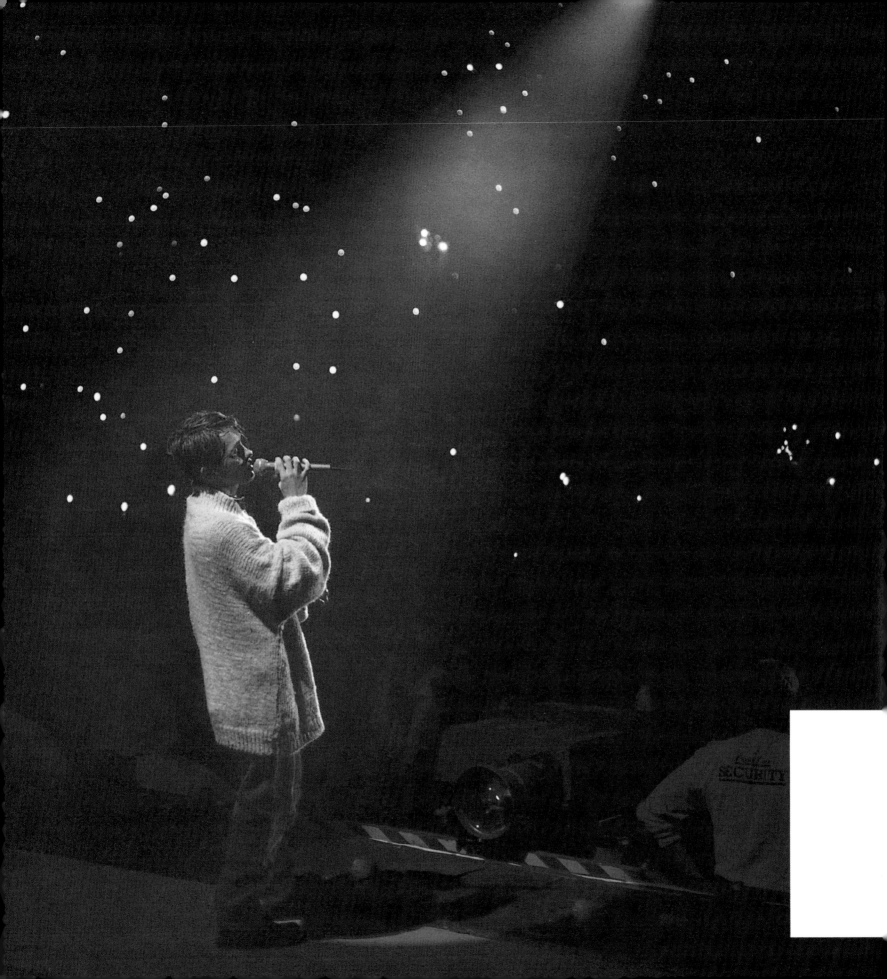

The same evening, after the gig, the private bar on the seventh floor of the East Berlin Hilton Hotel is the place to be. It's where Take That are having their private party.
Outside, fans whisper the secret to each other and try to figure out a way in. Inside, the hotel staff pass on the message that no-one – absolutely no-one – except Take That and their guests are allowed in. Way up high, remote from the chaos below, Gary and Mark stand up against a full-length window and stare down at their fans.
Mark: Let's go down and have a chat with them later, shall we? I feel sorry for them out there in the cold. Behind them, the mums and the rest of Take That – excepting Howard who has no special visitor and has gone to bed early – are sitting round a sociable arrangement of coffee tables on which there is a selection of large bottles of red wine, beer (for Rob) and toasted sandwiches. Glasses chink, sandwiches are passed round, jokes are gratefully laughed at.
These are precious times.

It has been an emotional night for everyone. During the gig Take That had beamed and danced and waved ecstatically to their families through what was almost perfection. During 'Babe' the crowd sang every word while holding their lighters aloft. Jan Williams swayed to the music clutching a teddy bear destined for her son in one hand, and a soggy tissue in the other. Marge and Colin Barlow did a lot of lip biting and Mary Owen smiled the exact same smile as her son. Jenny Orange turned to gaze at the vast auditorium lit with tiny flames of admiration, she looked back at her son up on the stage and then wept.

After the show, the families gathered backstage, drinking coffee, waiting for their ride to the hotel. They were quiet. Gary's mum summed up what everyone else was thinking.

"I always thought that Gary would do well but I never saw Take That. This new lifestyle. . . it's very hard don't you think? Sometimes when Gary phones to tell us I listen but I can't imagine what it's like. Then I come out here and I see all this and it's. . . it's just so hard."

Now they sit together - four families united by one cause. Take That.

"This is so nice," sighs Jason's mum. "All of us apart and now we're all here together."

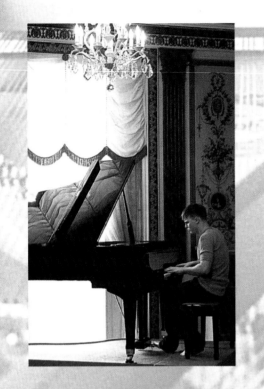

Then the gossip starts. And like most mums what they love doing best is embarrassing their offspring!

Jan Williams: What do we think of Robert's tattoo? He keeps asking me for my approval and I say to him, "You know how I feel about tattoos." And he says, "But don't you like it just a little bit mum?"

Mary Owen: I don't like tattoos either but Mark's is alright.

Tracey Owen: He wanted me to have one done with him because he was scared! He was going, "Go on, I'll pay for ya!"

Gary sits at the piano in the corner of the room and starts to play old favourites: 'Yellow Brick Road', 'Wind beneath my Wings', 'Bridge Over Troubled Water'. Tracey Owen joins him and shocks everyone by singing magnificently. Mark grins: "See, she's the real talent in the family. But you can't shut her up once she starts!" Suddenly the door opens. It is Howard, drawn here by the sound of the music and the warmth of the conversation. He is given an affectionate hug by Jenny Orange. He smiles, sits at the piano with Gary who puts an arm around his shoulders and gives him a welcome hug. The scene is complete and an overwhelming sense of well-being permeates the room.

By 3.30am the last mum has gone to bed and the bar bill is £470.00.

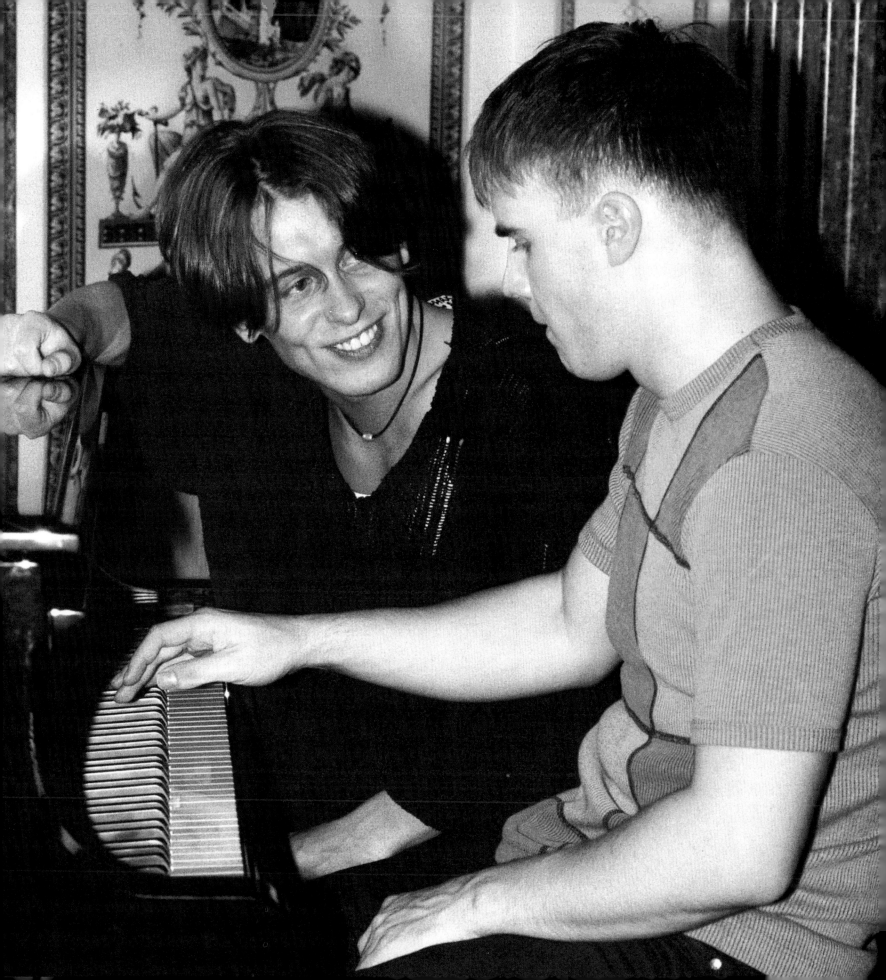

" I would have **risked** getting **shot** to be with my family. I'd have taken my time and planned my escape from East Berlin **very** carefully."

Jason

The following morning Rob and Jason are dragged by their mums to see **Checkpoint Charlie,** Berlin's most famous landmark. It takes Rob approximately three seconds to survey what's on offer before he suggests to Sally and his mum that they'd be best off having a coffee in the Café Adler across the street. Jason, however, is transfixed. He stands in No Man's Land, the strip of dirt track which once stood behind the Berlin Wall and separated East Berlin and the Communist world from West Berlin and the so-called free world. Here, people were shot trying to cross the expanse to join their families on the other side.

"Museums are boring," Robbie huffs as he slumps against the wall of the Checkpoint Charlie museum. He desperately doesn't want to go inside. "Oh, alright then. If I **must**. . . " Once there, however, he is riveted. Both he and Jason are suspended in awe and horror by the exhibits and tales of cruelty and bravery.

On their walk back to the hotel they are almost silent. "I'm feeling very emotional," says Jan Williams. Jenny Orange agrees: "I think it's been a very emotional few days." Jason walks behind his mum and smiles at her trainers and slouch socks. "Look at my mum. Isn't she cute with her trendy gear."

Ten minutes later they're back at the hotel where Howard is sitting on the corridor floor. He is bored and hates this waiting around. "It's the worst bit." All around him is confusion. The mums are late for their flight and the group have to leave to catch their own plane to Copenhagen. Emotional **goodbyes** are being said. Bags are being loaded onto trolleys (most of them almost clipping Howard round the head). Jason is taking pictures of his mum, Jan is giving Rob some last bits of motherly advice: "Now remember, put lavender oil on your pillow every night to help you get to sleep, love." Mark has a sore throat and is getting some last-minute sympathy from his mum and sister. Gary moonwalks (badly) behind his parents chirping: "Eh! Watch out for me! " Jenny Orange comes giggling down the corridor.

"Don't tell Jason I told you this but I was just in his room and he picked up this wacking great capsule and he was about to swallow it with water. I said, 'What are you doing with that, J?' He said, 'I'm gonna take it mum.' It was a suppository! A huge great thing! I said, 'I don't think so love, you're supposed to put that up your bum.' And he looked at it and said,

'That's going nowhere near my bum, thank you!'"

She gives the grumbling Howard a big hug.

"Bye bye Howard, come and visit us soon."

Then she and the families are gone.

Last year Jason took his first proper holiday for ages and chose to take it alone. He packed a bag, his guitar, four books on self-discovery and some travellers cheques. For two weeks he hardly spoke to a soul. Most of the day was spent sitting on a secluded little rock he'd found, out of view of everyone, practising his guitar and soaking up the sun. Some evenings were spent taking his meals on his balcony, reading and trying to find himself. Believe it or not, he had a whale of a time.

But then, Jason is accustomed to being alone. He lives by himself in a small, modest flat and when he's at home in Manchester he often eats out alone, just him, a curry, a glass of red wine and a good book.

"I like it most of the time. **But sometimes, you know, it does get lonely."**

Jason

Although Jason's a bit of bookworm now, during his school years he avoided books like the plague. Consequently, he didn't get much of an education.

"I didn't bother much with school. I was just on automatic pilot. I took a few exams but I missed most of them. The ones I took I didn't get. Perhaps when all this is over I'll go to college. . . Although I am educating myself now really."

One of the things he has learned, he says, through being in Take That, is to handle explosive situations more carefully.

"I used to scream and shout and it wouldn't do any good so now I just stay calm. We're sane, we're adults, we can rise above all the bitching that goes on in the music industry."

Jason's new found self-control is a feature that crops up again and again. He decided some time ago to teach himself to play guitar. Since then, he's rarely seen without one in his hand. Any spare moment is spent practising. Says Mark: **"I love to watch Jason playing his guitar, his face is pure concentration."**

And then there's his eating habits. No fat, no dairy produce, no artificial sugars – except, of course, when he's scoffing his beloved curries! When he goes on tour he takes a small black briefcase in which he carries some mind-expanding reading material and some seeds – poppy, sesame and sunflower – which he sprinkles on his sugar-free

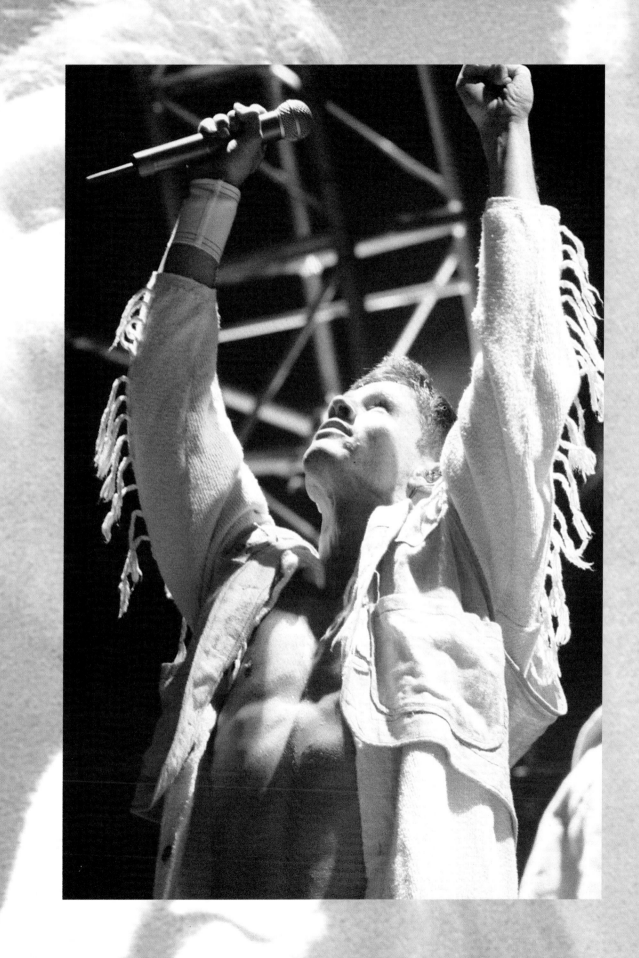

muesli doused with mineral water in the mornings. Extremely unappetizing.

"I just can't bare the thought of filling my body with crap."

But he has, it would seem, been overly abstemious of late. The first physiotherapist to visit him on this tour told him straight. "He said I was prone to injury because my diet was insufficient. I need more sugar, salt and caffeine to give me energy. I did have very low blood pressure because of my diet. . . "

On one particular occasion, Mark was so concerned about Jason's complete lack of energy that he forced him to eat some chocolate before he went on stage.

Jason has a very fierce sense of fair play. He gets upset when we visit a Swedish nightclub and the Take That musicians are forced to sit at a separate table because of space restrictions. It is he who insists that the musicians share the group's private jet to travel from country to country. Although the others groan when he "gets on a whinge" they also respect him for it.

"Jason won't have a bad word to say about anyone no matter how much they've pissed him off," says Rob, "he refuses to gossip or do people down and I really admire that."

"What right have I to judge anyone?" is Jason's reasoning. He says he leads as normal a life as possible given his circumstances. He still insists on going shopping about town

without a bodyguard, his only safety precautions being a woolly hat and a pair of clear glasses which he thinks are a disguise. Useless.

Gary is Jason's closest friend in the group and in true best mate fashion he has this to say:

"I pity the girl who ends up with **him**. Who would put up with **that**?"

Gary's mum, on the other hand, thinks Jason's pretty wonderful. "They're all lovely lads, but I think apart from Gary, Jason is my favourite. He seems to be very fond of his mother. He really is a lovely lad."

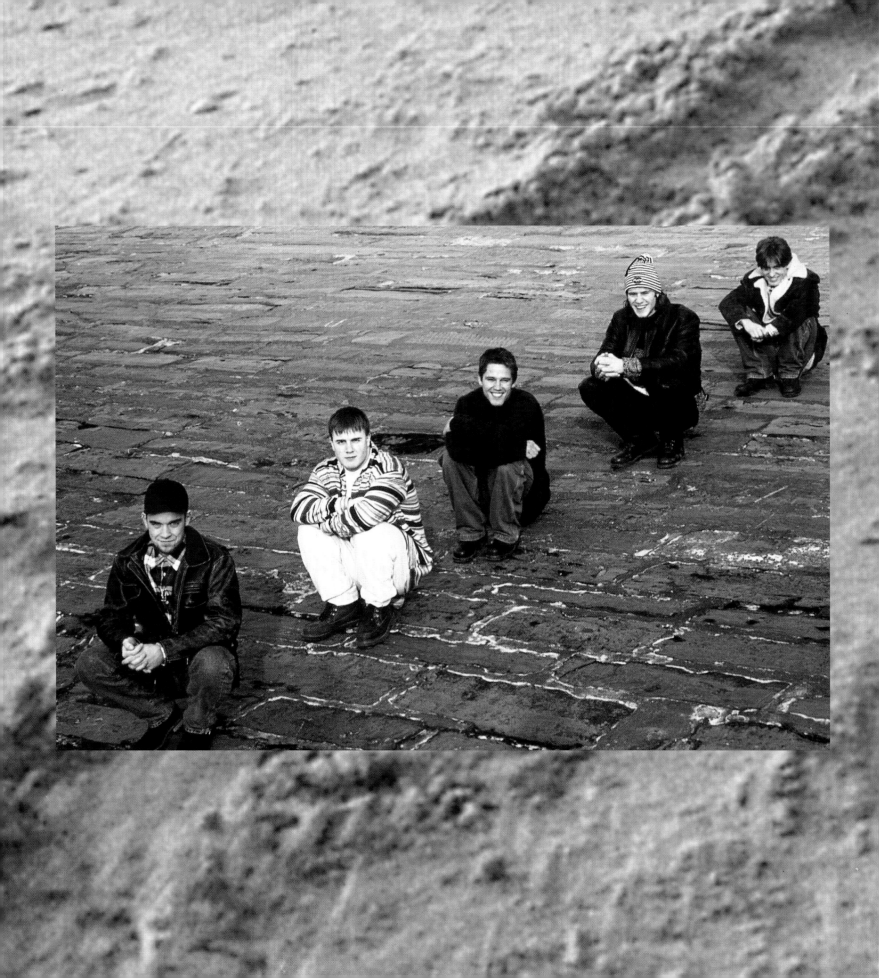

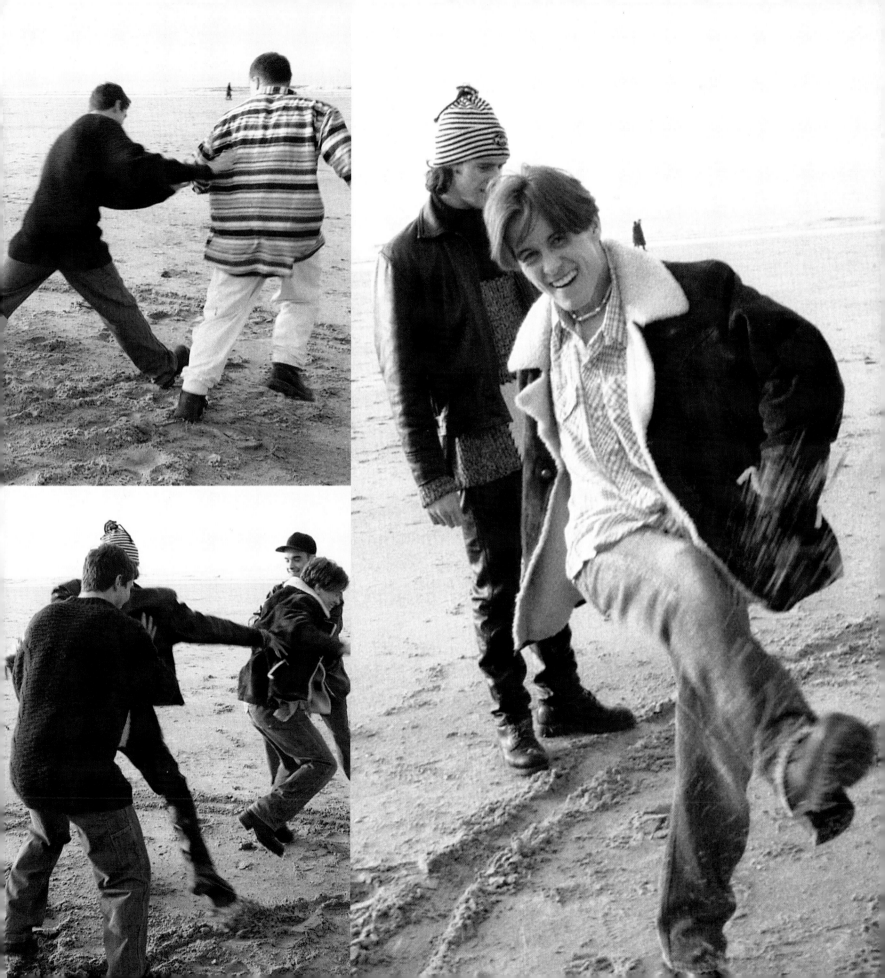

"Well, we've been spoilt here, haven't we!"

Howard is highly amused. To put it mildly, this hotel is not the best hotel Take That have stayed in.

There was a last-minute change of plan – the original hotel was besieged by fans and press and

this was all that was available. Whatever the hotel, Take That always have a corridor to

themselves to ensure privacy. It's costly but it's worth it. The corridor is guarded by two or three

security men who sit behind a desk at the entrance doors watching TV to keep them awake

throughout the night. Now Howard wanders in and out of the damp, sparse rooms examining the

rickety furniture and hard, narrow beds. He has declared it his job to see who has the worst room.

There is a yell from Rob.

"Eurgh! There're fleas in my bed! There're fleas!"

Fleas or not, Howard is tickled to find Gary's room takes the biscuit – **it doesn't even have a bath.**

He knows how much Gary values his home comforts and the fact that he has absolutely none is a

big cheerer-upper!

By the time Take That are ready to leave the hotel the following day for the soundcheck at

Copenhagen's Valby Halle there are three photographers, two journalists, a TV crew and all the

fans who were outside the other hotel, waiting to catch a glimpse of Europe's hottest pop

property. James, the genial head of security, looks out through the glass doors at the jostling

crowd which stands between Take That and their coach. There is simply no easy way to do this.

He nods to Paul, one of his team, steps outside, shouts: **"They're coming through,**

please stand back!" and deftly whizzes Take That through the crowd.

The fans surge forward and the photographers bustle and shove their way to the front. A girl falls down the steps and seeing her disappear under trampling feet Jason breaks free from his bodyguard's hold, runs back through the screaming mass to pull her up and out of the crowd to safety.

"I'm sorry, I'm so sorry, are you alright?" he asks. She nods, more stunned at this special treatment than anything else as she watches him dash back and into the safety of the coach.

The doors swing shut.

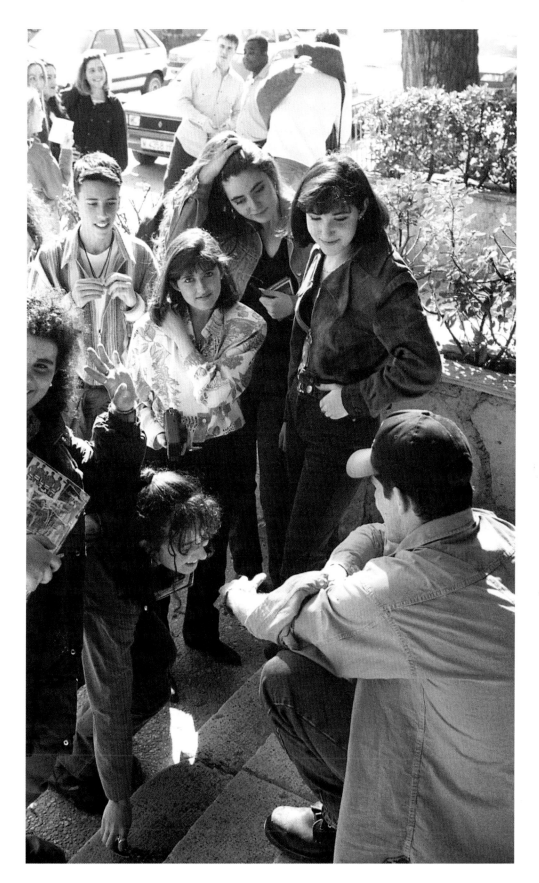

Duties before a show are often as demanding as the show itself. For Take That the evening's work starts at around 4.00pm with the soundcheck which takes about half an hour and is quite often a hilarious and somewhat degenerate affair. Sitting or standing about the stage they each hold a microphone while the sound bloke does some confusing technical stuff which only sound blokes know about. Gary launches into a practice run of 'Crack in my Heart' which he introduces as 'Crack in my Arse' and changes the opening line of,"I am just one man with one pair of eyes," to, "I am just one man with one pair of gonads." That's it. Any semblance of seriousness has just flown out the window and the next twenty minutes is spent with the crew, the group and any onlookers giggling helplessly.

The next duty is what is referred to as a meet 'n' greet. Some twenty or so girls who've won competitions to meet Take That are waiting tensely in a room at the end of the backstage corridor. As Robbie, Howard, Mark, Jason and Gary amble into the room the girls crowd around them offering presents. Rob meets his first Danish girl. "Why are you speaking backwards?" he asks. She giggles shyly.

Gary stands in the middle of the crowd and shouts at the top of his voice: "Gerroff! Gerroff! Leave me alone!" It's a private joke – at these meet 'n' greets none of the fans talk to him and he's often left standing alone in the middle of the crowd. He thinks it's hilarious. Jason rescues him by going over and introducing a few fans to him. Jason has been given a present. "A present! I've actually got a present! Any more?" Like Gaz, he often makes fun of the fact that he has less fans than the others. Earlier today he was sitting in his hotel room when girls outside started to chant his name. "Now there's a novelty you don't often hear - they're calling for me!"

Gary comes over, beside himself with laughter. "I feel really sorry for that girl over there. She's drawn all over her face with her biro and she doesn't realize it!"

Rob leaps across the room and puts his head close to Gary's and whispers between giggles, "Have you seen that girl with the pen on her face?"

Jason joins them wiping his mouth. "Did you see that girl? I went to give her a kiss and she stuck her tongue right down my throat!"

Howard has a better one. "I've just eaten a bloody great banana and I think she must have sucked half of it out of my mouth!"

Presents are given (Mark collapsing under the weight of his pile of chocolates, flowers and teddy bears), some kisses and autographs follow and then it's time for another type of meet 'n' greet which, interestingly, doesn't last nearly as long. It's time to meet the local record company and press bigwigs who are waiting quite nervously in another room. "We have to meet Jorgen Florgen from Morgen magazine," says Robbie cockily. For many of them, it's the first time they have met this new English group who are conquering the world and it is an unnerving experience. Take That work the room in perfect synchronicity, circulating in time, pressing flesh, cracking jokes and patting backs. It's a far more formal and perfunctory version of the fans' meet 'n' greet, **and it's good to see where their real loyalties lie.**

"*A* **present!** *I've* **actually** *got a present!* **Any** *more?*"

Jason

Next on the agenda is a list of press, TV and radio interviews, the most important of which is with Danish national telly. The interviewer is a middle-aged woman who explains that she is here to do an interview for the evening news and then another for the morning news. Take That nod happily.

The cameras roll and Take That sneak a quick look at each other. The interviewer has, at this stage, done nothing to upset them but it is as if a telepathic communication has passed between them. They are suddenly uncomfortable - they know this isn't going to be good.

Interviewer: When did Robbie last go on a date?

Robbie is taken aback.

Robbie: Erm. . . I honestly can't remember.

Interviewer: Do you ever long to be normal boys from Manchester again?

Howard: I think I still am.

Interviewer: Why do people admire you? Your looks? Your moves?

Jason: I think as Take That we try to put on a good show, we work hard at it.

Interviewer: What do the fans want from you, because they don't want to sleep with you.

Robbie: (Attempting a joke) Oh they definitely want to sleep with us!

Jason: Well, they all want to sleep with Robbie - or so he thinks! The interviewer thanks them and explains that that was for the evening news. Now for the morning news. She hands over some embarrassing white caps with the morning news logo emblazoned on the front. At this point, still happy to oblige, they put them on and grin and smile for the cameras for a few moments.

"Oh we like these, don't we Gaz," says Jason with a sarcasm that only his group mates would detect. "Yeah, we'll look smart in these," says Gaz.

The others suppress their giggles.

Interviewer: What do you think of Danish girls?

Jason: We think Danish girls are great.

Howard: I like Danish bacon.

Mark: I like Danish pastries.

Gary is getting a little impatient and decides to steer the interview towards something more relevant.

Gary: Let me tell you a bit about what we all do. I write most of the songs and Jason and Howard do all the choreography.

Mark can't resist it.

Mark: I set all the lights for the show.

Rob catches on.

Rob: And I set all the **pyrotechnics and sell bootleg tickets** outside the venue which is very important in the current economic climate.

The interviewer gets her own back and gets to the point she's been heading for all along.

Interviewer: Isn't it your looks more than your music that you are selling?

Jason: (Still keeping his patience while Rob and Mark exchange glances with Gary and Howard.) At first maybe people were only interested in the looks but now we're all learning instruments and I don't think that you can sell a triple platinum album on just good looks.

Interviewer: (Highly sarcastic now.) Oh, so when will you be playing your instruments then?

Mark: When we're old and grey. Can I just say that if this is the morning news I liked the evening news much better.

Rob: Look, some of us can play instruments - not me, I might add. But that's not the point - we're not U2, we're entertainers. You wouldn't ask U2 when they're going to learn to dance properly would you?

Interviewer: But your critics say you're not a proper group if you can't play.

Gary, the future winner of not one but two Ivor Novello awards for his musical achievement, has had enough.

Gary: Look. Is this all going to be negative? Because if it is I don't think I want to do it.

Jason: (appeasingly.) No. You're right. There will always be the critics but if they came to the show they would see that we're more than just faces.

Mark and Robbie aren't satisfied.

Mark: Critics? We haven't got any critics.

Rob: And they've all got **halitosis** breath anyway.

Gary: Shall we leave it there.

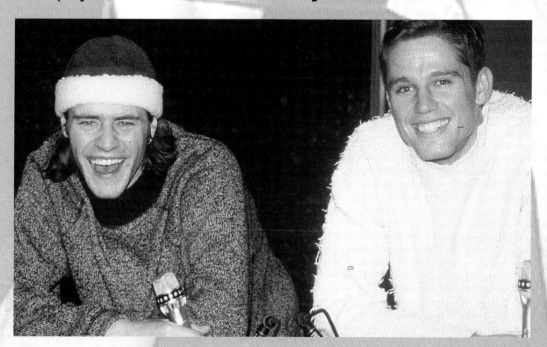

"That's the one! That's the shop! Oh yes, Barlow can smell it now! There's a bargain in there." Gary is leaning out of the car window like a man possessed. There is only one thing he's as passionate about as he is about songwriting and that's shopping! But if you embarrass easily, don't accompany him on one of his sprees. Inside the shop of his desires, in Copenhagen's antique district, he fingers a small, silver cigarette box. He has just been told the price.

"*How* much?! Oh I don't think I can afford that."

The snooty woman behind the counter looks over her half-moon specs at the scruffy anoraked character before her as if to say: "Hm, I thought as much!"

Gary slowly smirks, takes a deep breath and whispers,

"Right this is where the embarrassing bit starts."

He looks the woman straight in the eye and says: "Well now, I know what the *shop* price is but what are you going to sell it to *me* for?"

"Oh no sir, the price is not negotiable."

How wrong she is, for little does she know she is face to face with **Bargain Barlow, expert shopper and renowned bargain hunter!** He is obsessed with home improvement and the one thing that gets him through the difficult times on this tour is his planned visit to Harvey Nichols when he gets back to London.

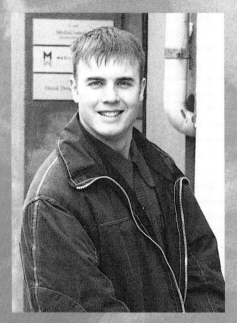

"There are two things I'm looking forward to, buying a bed in Harvey Nichs and getting a dog. I want a German Shepherd. I'd like one from a rescue foundation – one that really needs a good home. I can't wait."

Gary knows what he likes and his pleasures are simple ones. Croissants in the morning, coffee on the boil all day, Cadbury's Dairy Milk, and peace and quiet.

Gary is very confident about his songwriting, especially after meeting Elton John.

"He told me I had a talent and if I wanted to I could make a career out of songwriting for life. I had never thought about it before. From that day on my life changed."

He's not all confidence, though. He does worry about his weight.

"I can't tell you what I was eating during our month off – it would

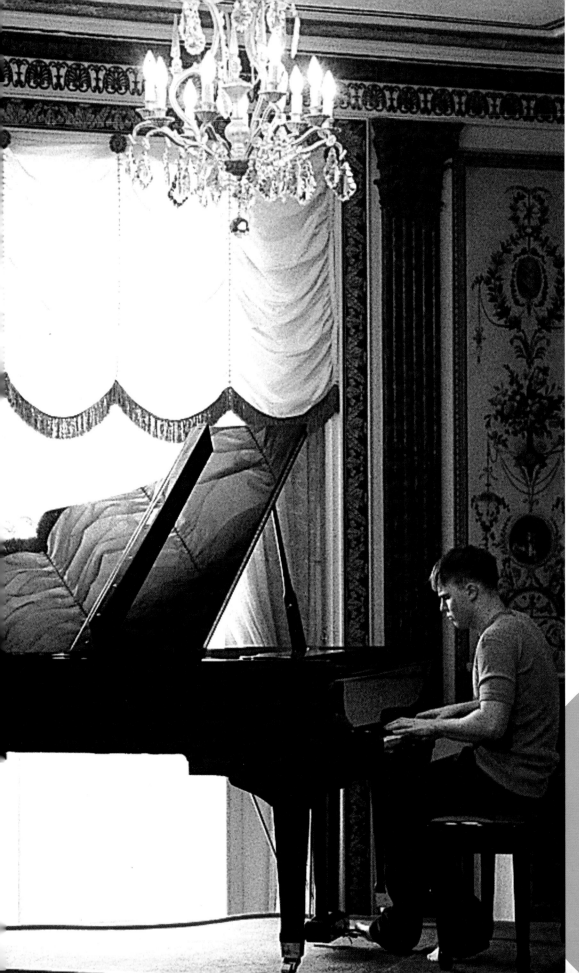

make you ill. One day I looked down and saw my gut. So I phoned Jason and I said, right, let's do a diet. I've been on it for a month and I think it's working."

The pinnacle of Gary's career – indeed his life so far has been to win two Ivor Novello awards. "For me that was recognition for everything I've tried to achieve. I was made up. "

Music is Gary's life. In his spare time he will write songs. One night, he finds a beautiful grand piano in the hotel restaurant and sits down to play 'Yesterday's Girl', a song intended for the next Take That album. He next plays a song he has written for his mum. He was in the loft a while ago and found some pictures of her when she was younger which inspired

him. "I haven't played this to my mum yet. I want her to get a surprise when it's on an album." A middle-aged couple stop by and look on, they have no idea who this person is but they are enchanted by his music. Apart from controlling his weight, Gary doesn't care much about the way he looks. In fact, he quite enjoys his anti-hero status. He recalls a time when a maid took photographs of his hotel room and was caught before she managed to sell the pictures to the tabloids.

"Can you imagine the shame?" he winces, "Gary Barlow middle-aged man with seventeen copies of *Homes and Gardens* by the bed and a pipe and slippers!" When he turns up at a restaurant

"Sorry girls, it's only **me,** the **others haven't come."**

without the other members of the group he apologizes to the convoy of fans who have followed him there.

"Sorry girls, it's only me, the others haven't come." Then aside: "I expect they'll all want to go home now they know the others aren't here! I reckon half the time we meet and greet fans they leave and they think, who was that scruffy bastard hanging round Take That!"

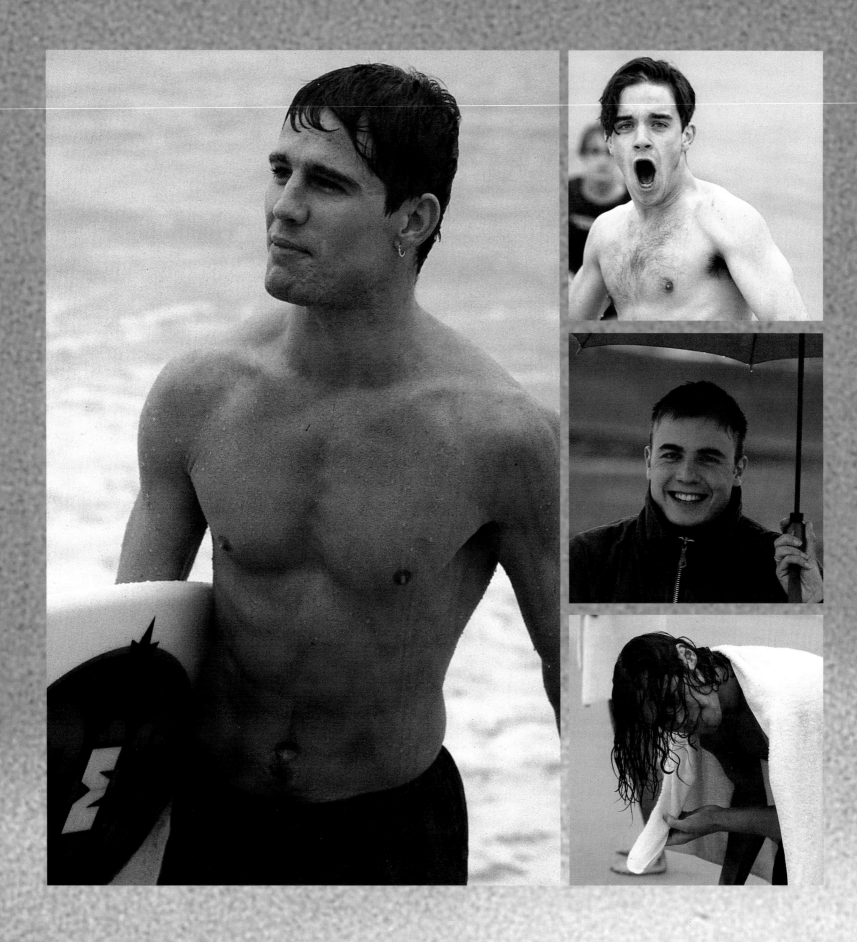

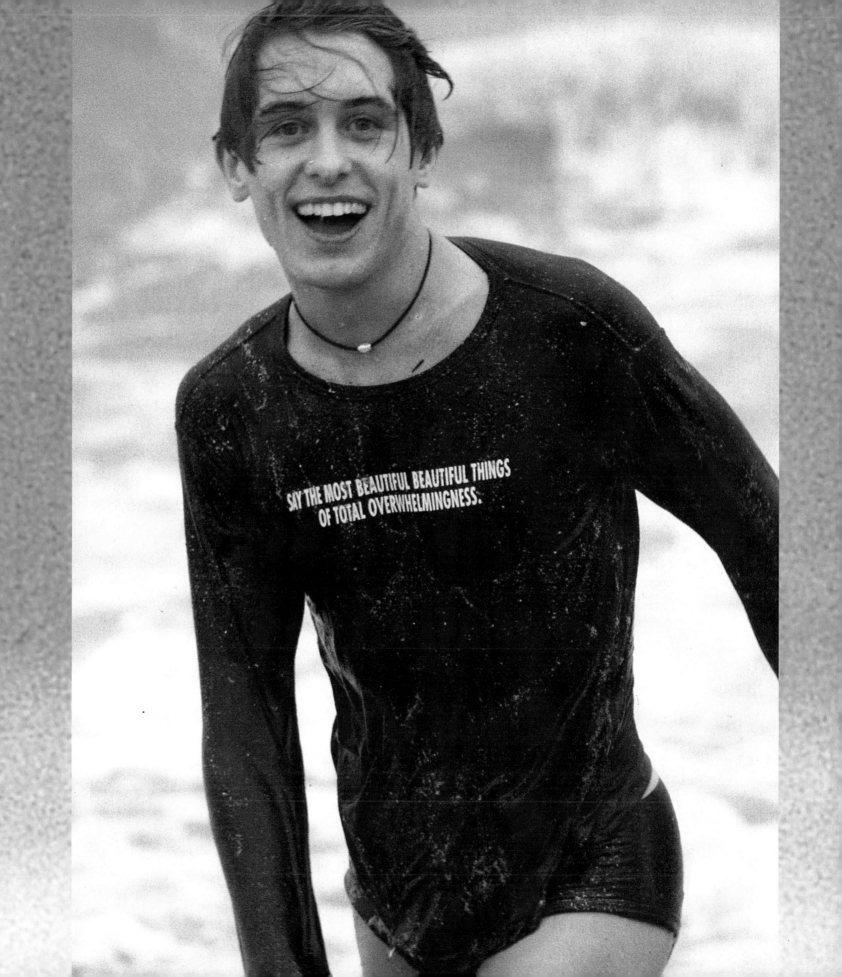

Take That are not the stars of this show. **Behind the curtains** the real celebrities are the crew who work like mental, making sure that everything out there on stage runs smoothly. Among the main people are Ying - Take That's long-time friend, assistant to the manager and production assistant on this tour; Jenny, wardrobe person extraordinaire and Skippy the tour manager and his troupe, whose military precision means that every prop, light and microphone is on stage on cue.

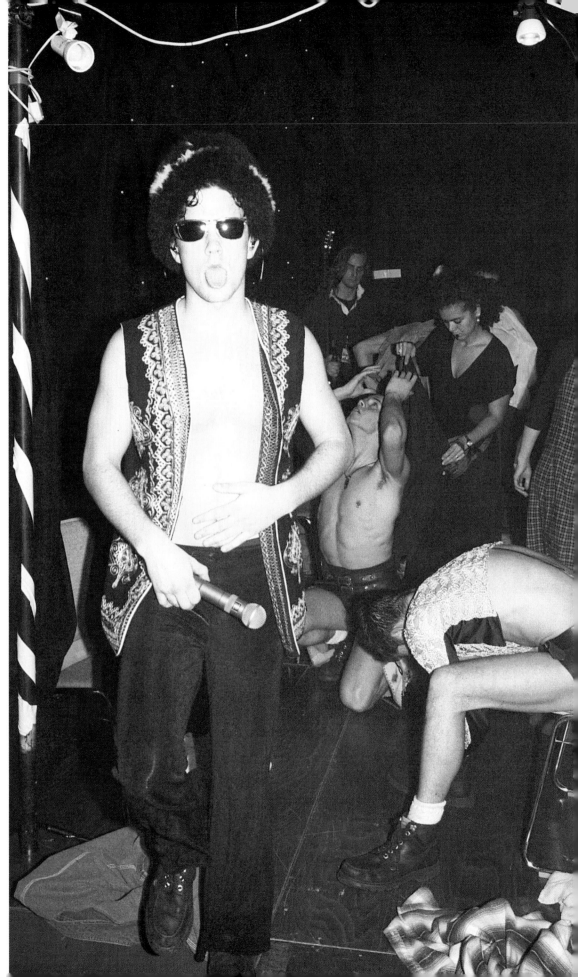

As the lights go down, the screams go up

and Take That position themselves calmly behind the curtains. Jason rubs at his arm. It's still giving him major jip. He asks the notoriously heavy-handed Mark to massage it for him. Glad to be helping someone Mark obliges.

"Ouch! Not too hard, Marky."

"Sorry."

Gary sniffs. "Oh, I'm all blocked up. . ."

Rob is drinking a cup of tea. There's nothing wrong with him.

With only a few seconds to go they **huddle together, eyes closed, kiss and take their places** on the central revolving panel which will get them and their props on and off stage throughout the entire show.

The first strains of 'Another Crack in my Heart' begin, Take That are on stage and a multitude of screams threaten to pierce the ceiling.

Whilst they dance their fluid dance to 'Wasting my Time', Jenny and Ying are frantically laying out gangster outfits for the next song, 'Whatever You Do To Me'. The guys run backstage, pulling off their clothes as they go. They slip into trick shirts and spats while the girls scoot around their feet doing up shoes. Mark rubs his face with a towel. **"It's hot out there tonight."**

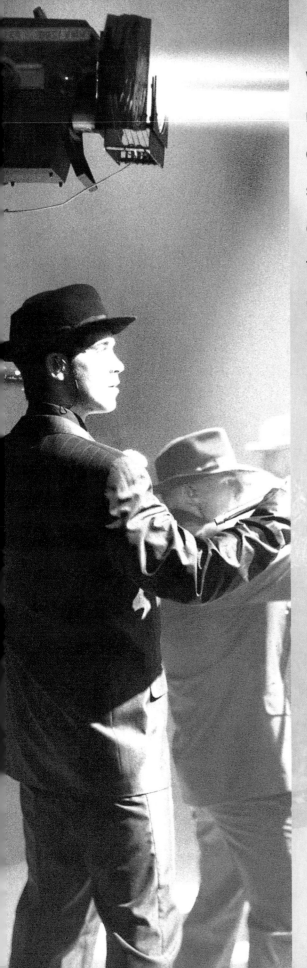

While Skippy clears the hundreds of teddy bears off the stage a crew man hands each member mic stands and Robbie a cigar before they dash back out **to ham it up Blues Brothers style.** While on stage a fake shoot-out is underway, Jenny is hanging up the previous outfit and Ying places white t-shirts and partially laced-up boots by the five chairs in the corner. Each TT knows which chair is his, throws off his coat and shirt and pulls a white t-shirt over his head while his boots are done up for him. Simultaneously, Ying and Jenny gather the gangster clothes up, balancing several hats on each of their heads and dash off to hang them on their specific hangers. If the wrong shirt goes on the wrong hanger, tomorrow night there could be a disaster. Imagine Robbie trying to squeeze into Mark's trousers with only a minute to spare!

By now the crowd are wild and wet with perspiration. Back here it's so humid with Take That sweat that you get soaked just standing still. Now the pressure is really on. On stage Robbie and Jason are announcing the next chunk of the show - The Old Time Medley. The central revolve is now a huge clock which ticks backwards. The group have 50 seconds in which to take off everything except their underpants and put on the now famous white and red outfits. Jason stomps his foot in panic. **"My lace is in a knot - I can't get my boot off.** Ying!" he pleads. Ying bends down, undoes the boot and takes it off.

Mark helps Howard pull his sweatshirt over his head, he does up Rob's trainers and just makes it onto the revolve as the last second has ticked by and they swing round to face the audience.

Now it really heats up backstage. The crew are lining up the scenery for the next scene - the 50s medley. While Take That dance and sing and backflip their way through the songs from their first album, 'Take That and Party', a dummy which looks like Jason in a frock is hauled up on stage, along with a dress and wig for Jason and satin jackets and jeans for all of them.

On stage the last line of 'It Only Takes a Minute' is echoing. The lights are off and TT are bounding backstage already tugging at their clothes. They are sweating so much now that they can barely get their outfit on. Conversation is minimal.

Jason: Any water?

Someone hands him a bottle. He gulps it down. Howard snatches it. Gulps. Then Rob. Meanwhile, Gary is in another panic. "I need the toilet! I'm desperate! What am I going to do?"

Mark: You should have gone before you came on stage!

Rob: There's no time Gaz.

They're back on stage for their now infamous rock 'n' roll medley. Jenny is placing a checked shirt over the back of each of the chairs and a pair of boots on the floor beside them.

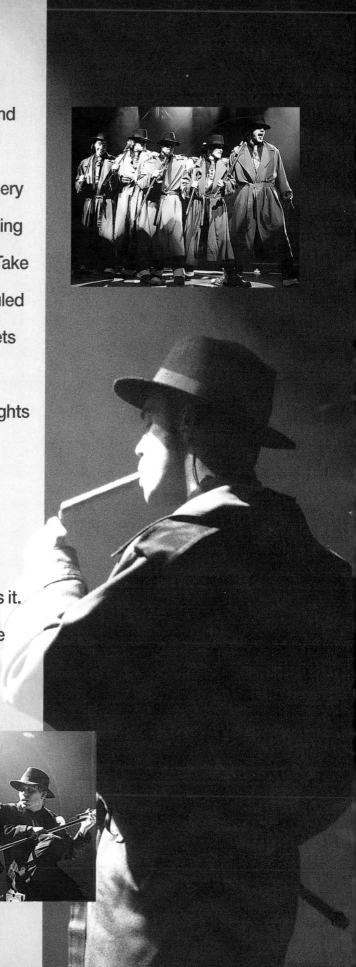

Mark rushes backstage in a fair old fluster yelling, "Cuckoo! Cuckoo!" "Cuckoo" is the code word that TT use to signal that they've spotted an unofficial photographer in the audience. Apparently, Mark Owen has been yelling "Cuckoo" until he's fit to burst and no one has taken the slightest bit of notice!

Now Gary is at the piano cooling things down with a couple of ballads. This is the time that the other four can have a rest. They amble slowly backstage. "This is our favourite bit," explains Mark: "We can take a bit more time to change."

They towel down and sip water, trying to regain a little energy. While Gary is putting his heart and soul into an angelic rendition of 'A Million Love Songs' on stage, Mark is belting it out pub-style behind the curtains: "A million luv songsah bayyyybee! And 'ere I aaaaaaaaaamah!"

Jason, meanwhile has been given a freshly tuned guitar and taken his position on the arm of the 'Babe' armchair. Mark squashes down onto his lap just to irritate him. Before Jason has time to complain, they are revolving onto the stage. Out front **thousands of little lights twinkle** in the darkness as the whole auditorium holds up a lighter and sings every word of 'Babe' with Mark. He takes the monitor out of his ear so that he can hear them sing. **He is enchanted.**

Backstage, Howard is patting the top of his head to check his hair is still there. "It's so hot out there tonight, the stage is small and the lights are so low they're burning my head! The stage is full of sweat and it's really horrible. And slippery."

Rob is not needed on stage now for about five minutes and so he goes off for his regular "tea and wee break". He visits the loo and

then sits in the catering area reading his stars in the Daily Star, munching sandwiches which are meant for the musicians after the show.

"Oh, I've eaten them all. . . oh shit." Then, "Oh shit! Is that Howard I can hear singing on stage? **I'm late!!**" He dashes off dropping the paper and stuffing the last crust in his mouth. As Gary finishes 'Love Ain't Here Anymore', the other four skid backstage.

"Tricky change this, 'Relight My Fire' " says Jason. He spits and grinds it into the floor.

While Take That are paying homage to a video of Lulu during 'Relight My Fire', Jenny and Ying are laying out the white shirts, velvet trousers and monk's habits for 'Pray'. **"Only ten more minutes to go! Yeeeeeeaaaah!"** they scream together. **They are exhausted.**

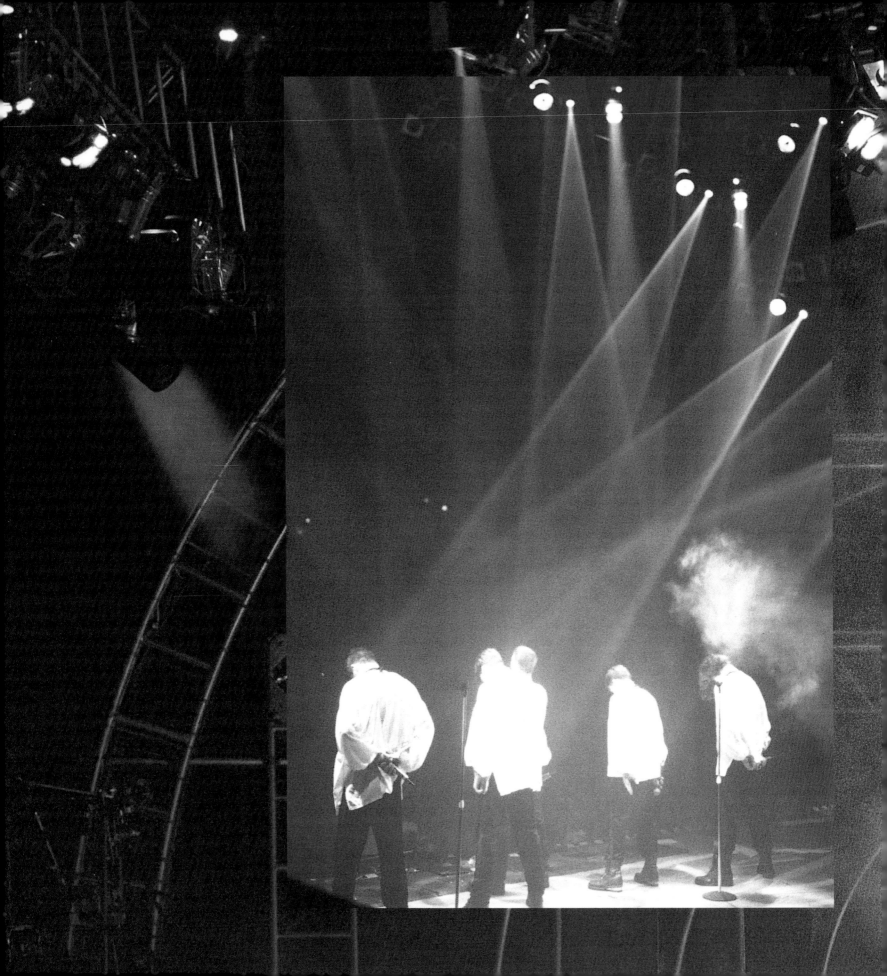

As TT line up at the curtain's edge, each with his hood pulled over his head to hide his face, **the thunder of thousands of feet pumelling the arena floor makes them shiver.** As they step out onto the stage and throw down their cloaks **the place erupts.** 'Pray' is the most theatrical and spectacular part of the show and the audience are beside themselves in a frenzy of love and appreciation. By the time the group have sung the last line of 'Could It Be Magic', security chaps Bert and Barry are standing at the bottom of the stage steps with black bathrobes and a white towel for each of the lads. As they run to their waiting van a towel is slung round each neck and a robe slipped over their shoulders. They sprint out into the cold night air, launch themselves into the back of a van, empty except for bean bags to break their fall, and by the time the last bar is being played on stage, **they are speeding off into the darkness.**

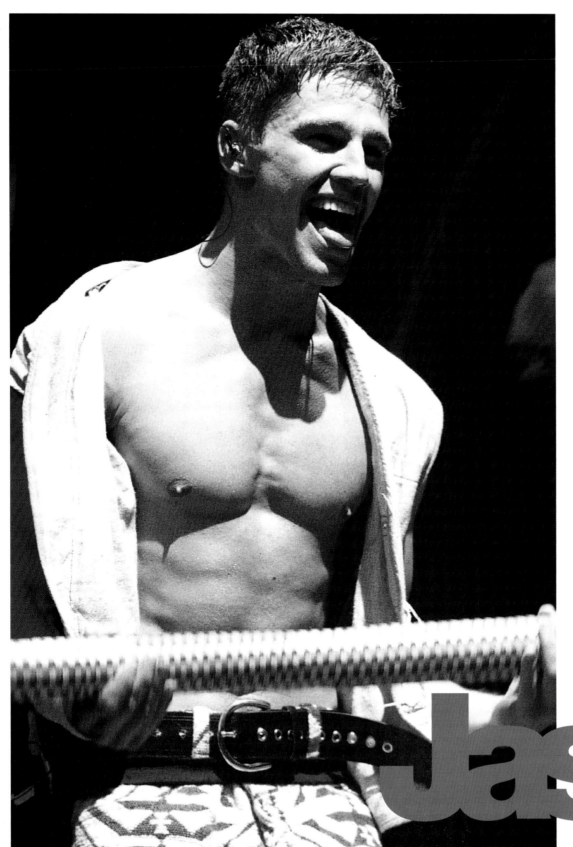

"
We like our

shows to have an

explosive

start, a bit of

entertainment

and some jokes in the

middle, and then for

the last five minutes

we go completely

Jason

mental"

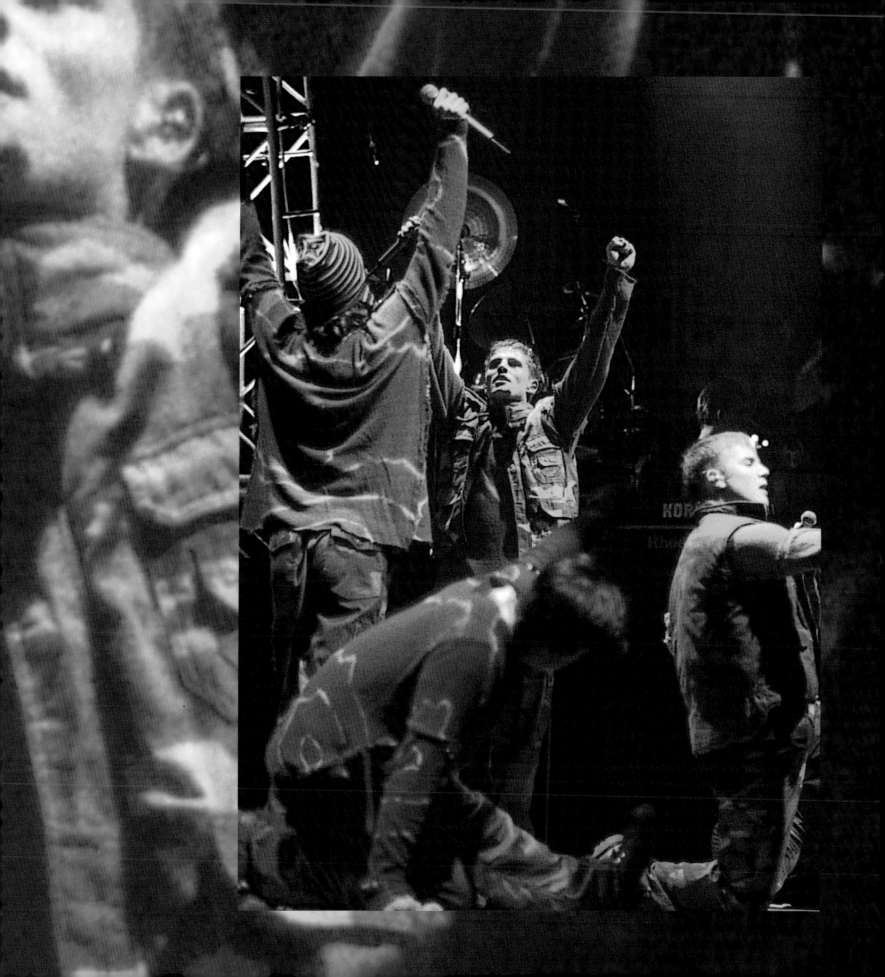

"We're an eating band," Take that once said and the group that eats together, stays together. Backstage all five members of TT sit down to their ritual meal. This family event is sacred and never missed. The caterers, Eat To The Beat, have been travelling with Take That since their very first tour and know their habits by now. Sean and Lou, who run the joint reckon that Take That are the nicest group they've ever worked for. "They never complain and we've never known a group to be so grateful."

TT have few requirements really. Jason doesn't eat red meat and Mark is virtually vegetarian. All milk used in the cooking is strictly soya milk and any cheese is veggie cheese because dairy produce gives Jason phlegm. There is always plenty of fresh veg and on the end of every menu there are the letters FFS – fresh fruit salad. On a table against one wall there is a huge urn of coffee and another of hot water for teas and herbal infusions. There's always a healthy barrel of biscuits and sometimes, if Sean has time to make it, a big sponge cake. Everything they make is delicious.

Tonight there is roast chicken. Gary is beside himself with joy. He has two helpings along with Jason and Rob, and Mark plumps for the fish pie - only it's some odd Scandi-fish and fairly revolting. Mark leans across the table and whispers, "Does anyone want my fish? I don't like it but I don't want to offend the caterers."

There are no takers so when he thinks no one is looking he sneaks over to the bin and disposes of the offending food muttering, "Please don't let them catch me." Two minutes later he can't bear the deceit and blurts to Lou, **"Sorry but I didn't like the fish."**

e're an
ting band"

Robbie

Robbie sits on a flat stretch of the hotel roof smoking a cigarette. It's a fridge out there and he's not dressed for the weather but he doesn't seem to notice. He's climbed up here to be alone. To do some thinking. He's depressed. He's just heard that Nirvana's front man Kurt Cobain has died.

"He's leaving a daughter behind. . . "

Robbie's pop star persona isn't actually too far removed from his real personality: **He *is* a scream, he *does* always have something to say for himself, he *is* that cheeky, cheery chap** from Stoke that you see on television. The only problem with personas is that they only tell half the story. And Robbie Williams is a real dichotomy.

"You see, I like being funny"

Robbie is outspoken, funny, loud and protective over those he loves. The son of a stand-up comedian and a florist, he can crack a good joke and make you up a nice bouquet.

"I used to work in the flower shop, actually. I can do a £12.50 bouquet – a bit of gypsophila, a bit of green, and then your sprays. And I can do a nice ribbon for it too."

The only thing he couldn't handle in the shop was the money.

"I can't add up or subtract. I'm dyslexic. I'm bad with numbers and I get my b's, d's and 9's round the wrong way. I was a grade A student at school in the first and second year and then they put me into a middle class. It was very embarrassing."

He's still not good with money now. When he had none to spend he didn't much care, now he's financially comfortable, he doesn't quite **know what to do with it all.**

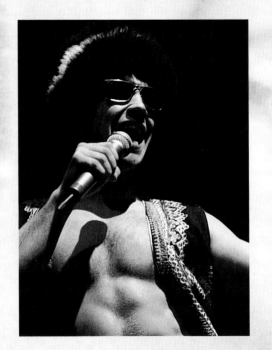

"I don't feel any different now I've got money to be honest. I still don't really spend. I bet I spend less than you do. I bet I spend less than anybody on this tour."

Robbie feels better about looking in the mirror now he's lost weight.

"I avoid all dairy produce and white bread. I eat tuna and lots of chicken. Sometimes when I'm at home I eat a whole chicken in a day. Just cold with a bit of salt on the side. There's hardly any fat on it, it's good protein and it builds muscle tissue. So instead of going to the

gym, I eat a chicken!"

His latest trick to get people to see how lean and muscly he is, is this: He pokes tentatively at a rib and says: "Ooh, I think I've broken a rib. Have a feel for me." So you feel about and find the painful part isn't a rib at all but a muscle. So he says, all innocence: **"Oh a muscle? Not another muscle!"**

Robbie relies on his own sense of humour for entertainment. "Sometimes if I haven't been very funny in an interview I get fed up. You see, I like being funny. When I read the interviews back afterwards I make myself laugh!" It's the other side to his character that many fans would find surprising. The other Robbie is the one who worries about his looks, who is concerned that he may have upset you – if he sees someone is down he'll say: "It's nothing I've done is it?" And he needs to be liked. And loved. "Since I've become famous I think it's more important for me to feel liked. You'd think it would be less, but I want to be sure that people still like **me**. "

He worries about fame changing him and is constantly asking if he's big-headed yet – he knows he's easily influenced but he's not stupid. "I don't think I've changed but, you know, it might happen and I might not know. I have to rely on people to tell me the truth." This most stridently heterosexual of men is very protective of his gay friends and is also very physically affectionate towards all women and men regardless of their sexuality.

"I go out with Mark, our make-up guy a lot – he's gay. So what if we go to gay clubs? I'll hold his hand going down the street if I want to. I'm just naturally affectionate. I always kiss the other lads in Take That hello and goodbye – no tongues though!"

The wind flaps across the cold, deserted runway on this palest of blue days. Howard stands alone clutching at the long tendrils of hair whipping around his face. He abandons any attempt to be heard above the shrill of the engines and waves a last sweet goodbye to Copenhagen and the record company reps. He lugs his bag aboard and takes his place next to Mark who is engrossed in a bathroom accessories catalogue. The plane hasn't even begun to taxi and Jason is leaning down the aisle.

"So! Are we on for tonight then, lads? Come on! We're going to Sweden and you know what that means! Café Opera! Let's have a big after-gig party! Yeah? **Well?"** Mark grunts from the depths of his catalogue, **"Yeah, I can wear me suit with the flares."** Howard looks up from the CDs he is signing and shrugs, Robbie has wedged himself on the floor between the two rows of seats and is snoring quietly. "Oh well, it was just a passing thought," says Jason weakly. Gary's head lollops backwards and forwards, his eyes shut and his mouth wide open catching flies. "That's attractive," comments Jason and settles down to jam his head up against the seat in front of him - typical scaredy-cat flying position.

We fly over the endless frozen seas and fiords towards Sweden. The landing in Stockholm is turbulent which excites Robbie. "I love turbulence!" he says taking great pleasure in seeing Jason's shoulders tense up.

There is no coach to meet the group on the tarmac, so they wait on the plane. Now Rob is impatient. "I just want to get off," he grumbles. Barry suggests we have a sing-song to occupy us while we wait. "Yeah, something by Niggers With Attitude," says Rob.

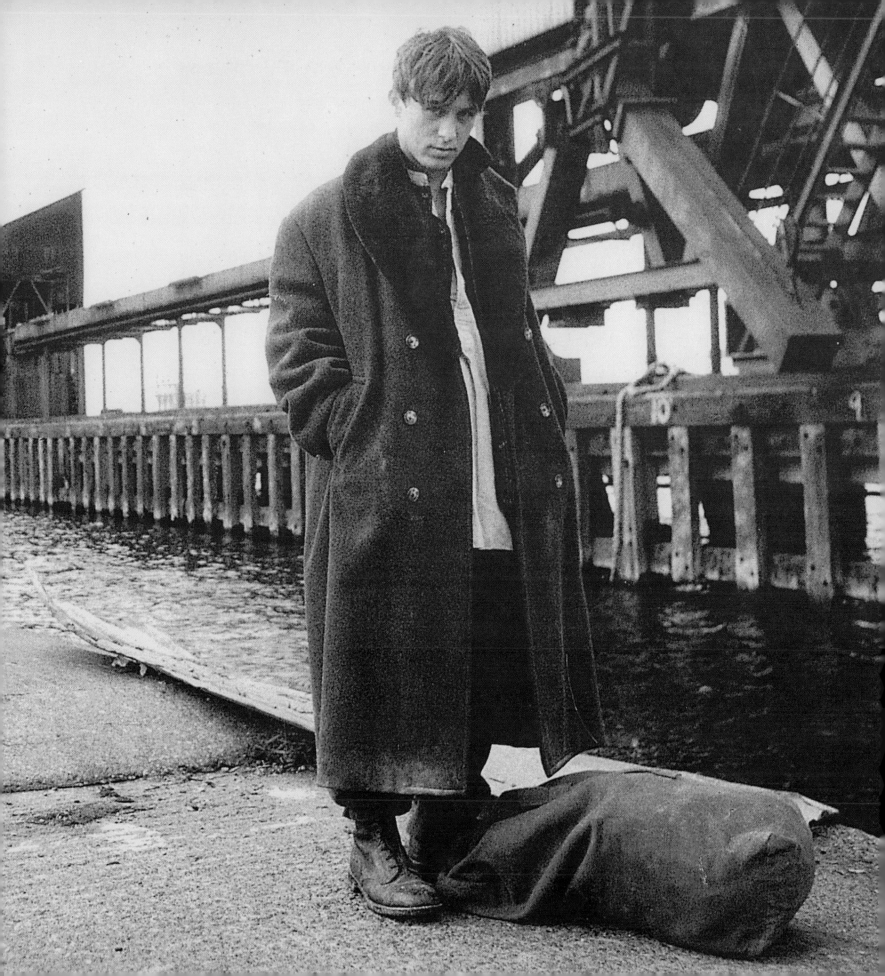

The Take That dressing room is a sanctum. No one except Take That, their immediate security, Jenny, Ying, Soozii and Nigel, who is, of course, the sixth member of Take That, are allowed in here. This is where Take That can be totally alone and honest with one another. In here no one can see what they're doing, make judgements upon them or ask them for autographs.

Jason enters the dressing room and Gary, Rob and Mark look up expectantly.

Jason: No news on 'Ow yet.

Earlier on at dinner Howard had been unusually quiet during pudding. Suddenly, his face turned a shade of green then red and his hands started trembling. He got up from the table, pushed his chair back and stumbled. An ever-alert security man rushed over and caught him before he fell. Tears were streaming down his face as he wobbled first into the wall and then out of the door.

Just then, however, Howard arrives. The doctor has told him he has a severe case of food poisoning, the result of a dodgy hotel meal.

Jason: How are you 'Ow?

Howard: Not good.

Mark: Just be sick Howard. You'll be a lot better, get it all out.

Howard: I can't be sick.

As he says these very words he claps his hand to his mouth. "I think I spoke too soon. Where's the toilet?"

Gary: Oh, it's all glamour with us innit!

Take That's dressing-room requirements are pretty undemanding in the grand scheme of rock 'n' roll. For most groups a rider would consist of bottles of Jack Daniels, a few crates of beer, flash food. All Take That ask for is some nuts and raisins, some sunflower seeds, plenty of Evian water, a pot of honey, a kettle of water and some slices of lemon. Pathetic! Gary puts the kettle on for their honey and lemon drinks. Every night about half an hour before the show they each sip this drink to help soothe their throats. Tonight, Mark's **too excited** to drink – "Café Opera tonight! I've hung up my suit - it cost me seventy quid in Oxfam and it's on it s little hanger, over the bath ironing itself."

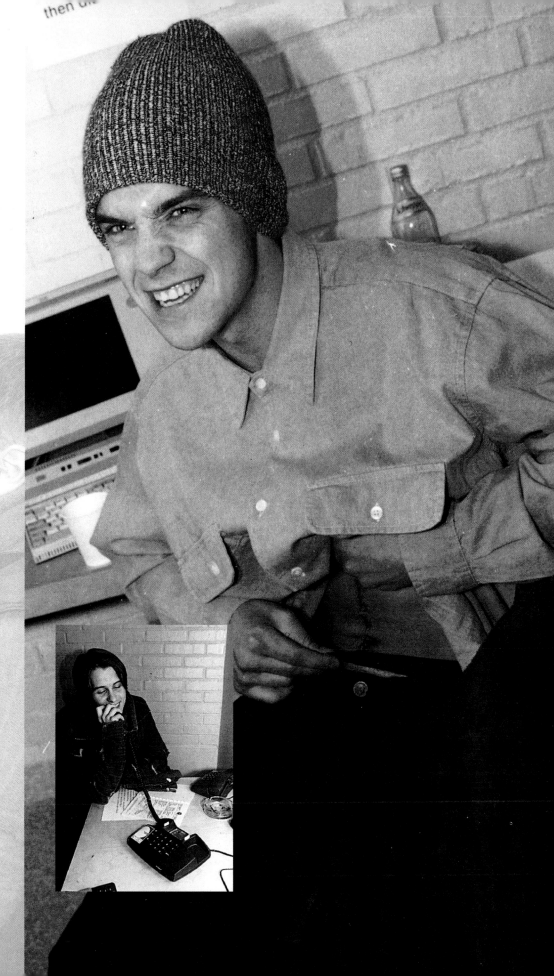

Gary is looking up at the beautifully painted renaissance ceiling in the Café Opera.

"Look at that. . . I wouldn't mind one of them in my house!"

Take That sit at their table, one side of which is against a glass wall which looks onto the tiny dance floor, the other side faces the general drinking, eating and ogling area of the club. The only person missing is poor Howard who is back at the hotel being violently ill. Gary laughs. "It's bloody ghastly in here isn't it? I feel like I'm in a fish bowl." Already there are people pressed up against the glass window peering in at the group while the area immediately surrounding the table has very suddenly become dense with "casual" passers-by. Robbie picks up a menu. There's not much on it except what can be pulled from the nearby fiords: cod, braised cod, unbraised cod, grilled cod, cod roe – you get the picture.

Rob: What's "bleak row on toast"?

Gary: Don't you know what bleak roe is? It's roe that hasn't been happy for a long time.

"Bleak roe" it turns out, is supposed to be "black roe" – or in other words, caviar.

Gary: I think we'll have some bread rolls and some chips – we can make chip butties. Oh yes, you get all the best meals with us. While they wait for the buttie kit to arrive Rob goes in search of Dr Alban. They were on the same bill together at a Euro-fest when Take That popped into his dressing room to say a friendly hello. But the singing dentist was too busy to chat and rather abrubtly asked them to leave.

Rob: In those days he was a lot more famous than us. I'd like to speak to him again just so that I could be really nice!

Gary: He's normally here whenever we are. I think he must live in here – and whenever we see him he's always doing that dance!

He and Rob get up and do a ridiculous hobble while slicing their hands up and down through the air Dr Alban style. They applaud their own humour, heartily.

By now you can't get near the Take That table. The throng press and shove past, glancing sideways to get a good look at the visiting pop stars. Some of the more confident girls – and blokes – stop and linger for a moment, others pass by two, three, even four times. One girl gives up all pretension of casualness and stations herself atop the next table and settles there to gawp unabashed for the night. **It is getting hotter and more fervent by the second.**

Gary: God, look at the white stilettoes in this place! And the fake tans. They must all sleep under a sunbed every night!

Jason: There's one thing wrong with the girls in this place they all wear far too much make-up. I've scanned the place. I like the natural look.

He wanders over to where the TT musicians are standing and joins their circle of chat. Immediately, a troop of highly made-up beauties close in on him. The one who gets there first looks triumphant as she smiles purposefully and introduces herself.

Jason chats politely for a while and eventually makes his excuses and turns back to his mates – only to be confronted with another girl who's wearing a kind of bikini top and what looks like a big belt but turns out to be a small skirt. Same scenario. Small talk and a polite brush-off. And another model-like, stilettoed and intensely blonde confrontation. She taps Jason on the shoulder, he turns, shakes her hand and says, "Excuse me I'm going to sit down."

Jason comes over to the table, shaking his head. "I don't mind chatting to girls but when they start singing 'Could It Be Magic' it's a bit of a turn off. It's all a bit too much. Sometimes I think it's nicer to see a girl sitting in a corner doing her own thing, being cool. In possession of herself."

The chips arrive and for a while there is contented munching. A girl and her friend sit with Robbie. They can't speak English but they are prepared to try very hard for Robbie. Robbie is genial, he pours them a drink of red wine each and introduces himself: **"Hello I'm Rob. I do have a yellow lemon plant but no brass door knobs."** The girls nod enthusiastically.

Gary looks on. "Oh he's cruel, that Rob, isn't he? It's his own fault he's getting bothered, though. He should sit in a corner like me."

But Gary has spoken too soon and there is a tap on his shoulder. Three women later and Gary is ready to leave. "Oh I just want to have a bloody conversation with my mates. Barry? Barry?"

Barry, who has been standing a few steps away with James and Bert practising the security guard's art of not overhearing personal and private conversations, turns to face Gary.

Gary: Barry, is the coach going back to the hotel soon? Well, can I be on it when it does? Thanks.

Jason: Oh Gaz you can't go home yet! I might come with you, then. Look, just have a dance with me first and then we'll go, yeah?

Gary: I'm not dancing out there.

Jason: Oh come on, please. I really fancy a dance.

Jason turns to the women in the party, namely Soozii and your author.

Jason: Well, one of you dance with me then. Come on!

Mark is having more success than Jason - but he's not enjoying it. He's

hyperventilating again as he executes a hurried and comical tip-toe across the room. He's talking without breathing.

Mark: Oh help, help, help! I've attracted a punk rocker with her bosoms squashed out of her top. They're all hanging out and she keeps saying to me, 'what you do later?' and I keep going 'I'm very tired I have to go to **sleep**'. I keep attracting all the weird girls. I think it's the suit. They can tell I got it from Oxfam so they think I'm their type! All the pretty girls are too tall. I can't dance with them. D'you think they'd care that I'm little?

Jason: I'll dance with you Marky.

Mark: I don't want to dance with you, find your own partner.

A girl comes over to Jason and leans seductively across the table. "Would you like to dance with me?" she husks and knocks a glass of wine into his lap. He looks at her for a minute then dryly says: **"No."**

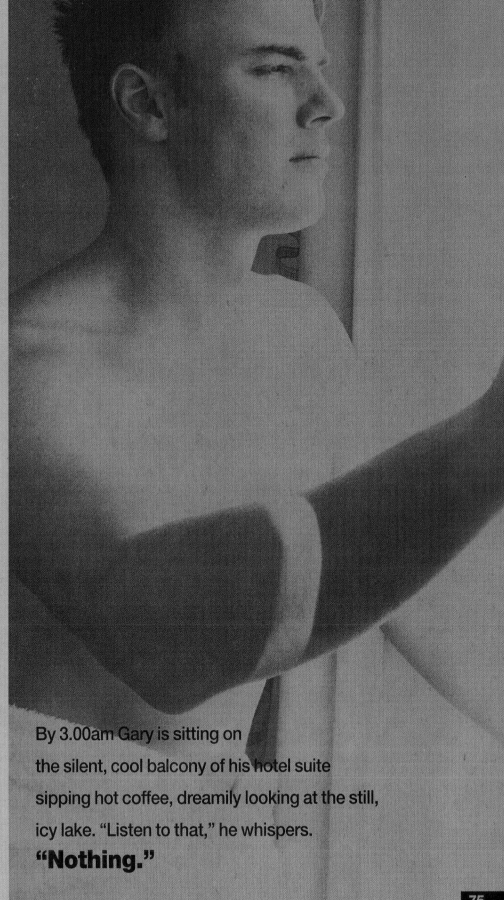

By 3.00am Gary is sitting on the silent, cool balcony of his hotel suite sipping hot coffee, dreamily looking at the still, icy lake. "Listen to that," he whispers. **"Nothing."**

"We've not changed have we? Fame hasn't made us into horrible people has it? Are we doing alright do you think?" Mark Owen is a worrier. It's his nature. Is Jason's ankle any better? Is Take That's stage show still fresh and entertaining? Are the girls outside the hotel cold? Are the fans getting their money's worth? It's no accident of nature that he's the heartthrob in the group.

"He is just cute. Really cute" says Robbie. "Even his trainers are cute and not smelly like everyone else's. And you know, if he signs an autograph for a fan, he can't just put 'Love Mark', he has to say who it's to, write a little personal message: 'It was nice meeting you, hope your gran's feeling well, give my love to your mum.' **He honestly thinks that they'll love him less if he doesn't do all that."**

Mark

he is just cute, really cute, says Robbi

"Even his trainers are cute and not smelly like everyone else's. And you know, if he signs an autograph for a fan, he can't just put 'Love Mark', he has to say who it's to, write a personal message – 'it was nice meeting you, hope your gran's feeling well, give my love to your mum' – he honestly thinks they'll love him less if he doesn't do all that."

Mark has won just about every award available where looks are the criteria being judged. And Gary worries about this.

"He says it doesn't bother him but it does. I worry about little Marky, it's a lot of responsibility."

For someone who's worry quota is so high, Mark Owen is a remarkably chipper chap. He has an endearing habit of talking to himself. He's often to be found wandering aimlessly, babbling away quite happily to no one in particular.

He sometimes goes into hyperdrive – especially if he's had a glass of red wine – he has no tolerance of alcohol whatsoever! And yet, the others in Take That have a quiet respect for him which is rarely spoken. Says Gary, "Marky has such good taste, you know, and he never boasts about what he's bought either. He'll turn up with a nice little car and you'll say: 'Oh that's nice Marky.' And he'll say: 'Oh I've had it for about six months now.' "

Mark rarely loses his temper. But the night the video crew polished the stage in Berlin, Mark stormed off stage and screamed at Skippy the stage manager.

"What the hell do you think you're doing letting them polish our stage?"

"I apologized straight away. I thought, hold on, this isn't me, I must be tired."

When Mark has had enough he likes to be alone. When we return to

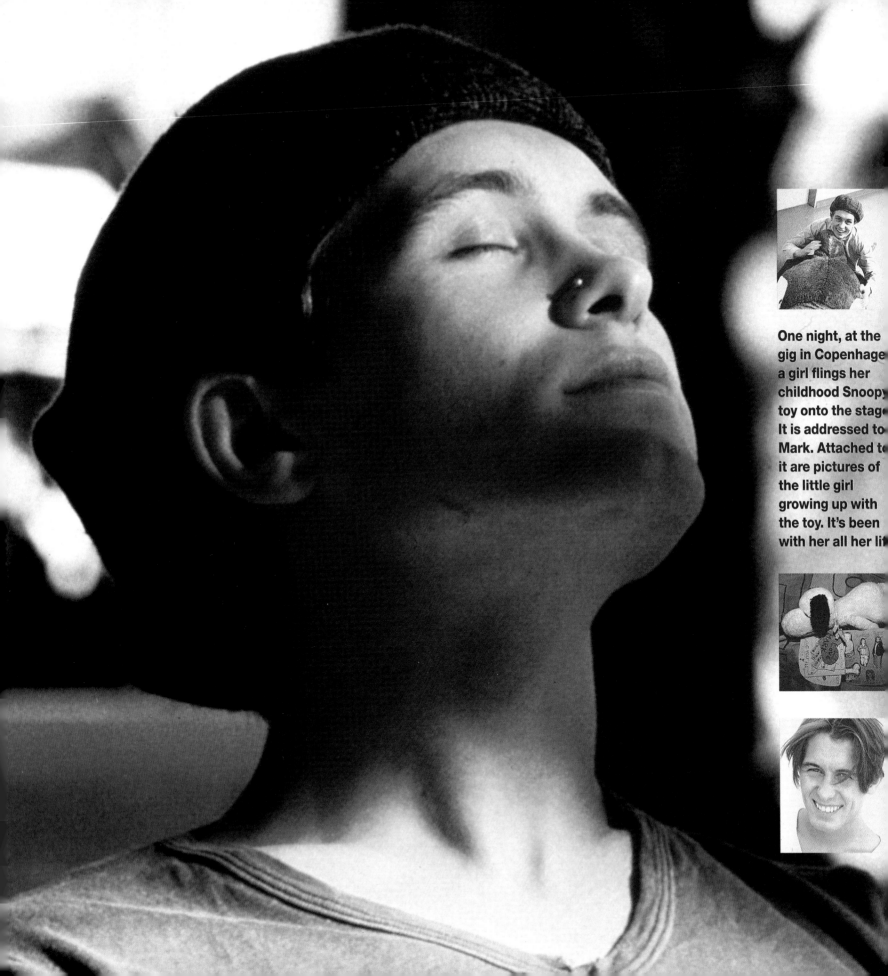

One night, at the gig in Copenhage a girl flings her childhood Snoopy toy onto the stage It is addressed to Mark. Attached to it are pictures of the little girl growing up with the toy. It's been with her all her li

London after this tour, he goes for a walk on his own, without security saying: "I'm sick of being followed everywhere, I want to be on my own."

"He likes his own company, does Mark, I admire that in a person," says Gary.

Mark is a real animal lover – at his mum and dad's house there is a budgie, a dog, a goldfish and a hamster.

Now he lives with his pet iguana, Nirvana, and he's a soft touch for a hungry cat, too.

"Where I live there are a lot of stray cats. At the moment I'm feeding about six of them!"

You would think, being Britain's and just about everywhere else's sexiest man, Mark would be full of sickening confidence.

Charmingly, he isn't. He is least confident about his singing.

"The other night on stage I could feel my voice going half-way through the show. I was so fed up I nearly cried. I'm not very confident about my singing anyway. When we had a month off last year I went and booked myself some singing lessons. I didn't have time to start from scratch so the woman said bring in some of your favourite records and sing to them. So that's what I did. I'd put a record on and sing and she'd tell me where I was going wrong."

One night, at the gig in Copenhagen, a girl flings her childhood Snoopy toy onto the stage. It is addressed to Mark. Attached to it are pictures of the little girl growing up with the toy. It's been with her all her life. The next day Mark writes the girl a letter saying that although he loves the Snoopy, she has had so much history with it that he can't possibly keep it. In his letter he explains that as he is on tour he doesn't have a box handy but he'll keep the Snoopy dog until he gets home and then he'll post it back to her. He keeps to his word.

"ribbet"

A spooky feeling is settling over Take That as their jet heads bumpily towards Helsinki. A late arrival at Stockholm airport meant there was no time to stop and chat with the fans waiting there and this has upset Mark. **"We seem to be getting less and less time to talk to the fans. It's not on."** Jason still hasn't recovered from his night out. He sits with his head jammed on the seat in front of him clutching his stomach. Gary's outing on the balcony did not help his cold, he is blowing his nose into the sick bag - the only thing he can find. Howard is still weak and feverish. Rob hasn't eaten anything proper for 24 hours and his hands are shaking. Gary looks out of the window. **"There will be a huge cloud over Helsinki. There always is. Oh God, I could murder a bowl of Frosties. . .Oh, the glamour of being a top pop star!"**

By the time the TT jet has landed at the bleak, military-looking private airfield at Helsinki, Jason has slumped considerably. He is helped down the three exit steps where he moodily crosses the tarmac to the awaiting coach. Fans wave wildly from the wire mesh fencing fifty yards away. He waves and smiles but once behind the safety of the coach's one-way glass he lumbers up the stairs and sits between Howard and Gary gripping his gut. The ill threesome sit bemoaning their fate.

Gary: Oh this is the **worst** cold I have **ever** had!

Howard must be recovering somewhat – he has now made the transition from being completely repulsed by food to being ravenously hungry. So hungry that food is all he can think of.

Howard: How long is it till we get to the hotel? I've got to eat. What do you think there is to eat? Is there any food on the coach? Has **anyone** got **anything** to eat?

Jason: 'Ow, can you shut up about food. I don't feel too good mate.

Gary: Oh look at us all.

He attempts to cheer up Jason by murmuring "ribbet" in his ear at close range.

This is their "joke", doing frog impersonations in each other's ears. Sometimes they leave twenty or thirty messages on each other's answerphones just saying **"ribbet ribbet".** They think it's hilarious.

Today, however, Jason pushes him away.

"Get off Gaz, I mean it."

Gary sits up and belts Jason on the head.

"Pack it in, Lander!"

Lander is their personal nickname for one another and is a reference to the film Highlander.

Gary's eyes light up as he senses the opportunity for some mischief. "Oh! Oh! I try to be nice but I can't do right for doing wrong can I? He's sending me away now."

Jason lurches forward clutching his increasingly sick tummy. Gary attempts to pinpoint this latest development in the deteriorating health of his friend.

"Have you got a stomach ache?"

Jason shakes his head.

"Back ache?"

Another negative.

"Front ache?"

No.

"Eye ache?"

Jason shakes his head once more and says pathetically,

"Bone ache."

Gary: (Suspiciously.) Does that mean you want a physio?

Jason: No don't worry Gaz.

Gary: We were making a profit on this tour before he started getting his physio out. **It sorts the boys from the men does a tour like this.**

Jason: I think it's tonsillitis. I used to get it a lot when I was little and I never had my tonsils out.

Gary grins at Howard who is encouraged by the very fact that

someone is iller than he is!

Gary: Oh, J, you'll have to have 'em out.

Howard: What's the oldest you can get them pulled out Gaz?

Gary: 23 I think (Jason's age). They do it with a great big knife. It's still got butter on it! Hee hee! And I also think they have to break your jaw to get them. Or is it your nose? Eh, maybe you'd feel better if I kissed your ear J.

Jason: No I wouldn't Gaz.

Gary: Oh! Oh! Right.

He relents and gives Jason a neck rub, only pausing to whisper "ribbet ribbet" almost inaudibly in his ear.

"ribbet"

The Hotel Kalastajatorppa's postmark would have it in **Helsinki,** but it is some miles outside the city, where it sits heavily on the expansive shore of a vast, pale, frozen lake. They may as well be in Siberia - in a James Bond movie. Each room is the size of a house. The bed - seven feet wide, no less - hardly fills a gap. There are low-slung swivel chairs, countless telephones (that don't work), smoked glass coffee tables, and an en-suite bathroom which gives the concept of kitsch a new dimension. And there's a button. A button which Gary has already discovered. It's to darken or lighten the huge picture window which runs the length of one wall and overlooks the frozen landscape. Here, time is all wrong. There can be blazing sunshine at midnight and at other times darkness all day.

Gary's on the phone. "Eh! Do what I'm doing! Sunbathing! I've taken off all me clothes and I'm star-shaped on the bed! The sun's streaming through the window and it's lovely and warm! Come up and see!" When we arrive, thankfully, Gary has wrapped a sheet around himself.

"I know we're a few floors up but I got worried. I did this once in New York when we were staying on the eighteenth floor of a hotel off Times Square thinking no one could see me. Then I heard a knock on the window. I thought, no I'm eighteen floors up, who's going to be knocking on my window? And there was the knock again. So I looked up and there was Robbie, grinning. He'd climbed the entire length of the hotel wall from his room to mine with only a rail and a six-inch ledge to walk on."

He takes two scented candles from his suitcase and lights them. He got the idea from Elton John who has them in every room of his house. Each lad's hotel room is his temporary home and is possibly his safest haven when the group are on a tour. They are completely alone here and nowhere else. The guards stop any fans entering the corridor and knocking on their doors. There is total peace and quiet and no one bothers them.

Gary sets the candles by his bedside and continues unpacking. He never takes clothes out of his suitcase - he has only three changes of clothes with him and they're all crease-proof! If they're not, "well sod it!"

He puts three editions of *Home Interiors* on the bed and a handful of pages he's torn out of other magazines showing bed linen. He's on the look-out for things for his house. In the bathroom, he has taken his razor out of his bag and is about to shave. He runs a bath. "I need a really hot bath and a good meal. I can feel a good rub [TT speak for Curry] coming on me." His tracksuit bottoms, anorak and sweatshirt lie in an untidy pile on top of his trainers. In five minutes he will dry himself off and step back into the same clothes except for a change of underwear.

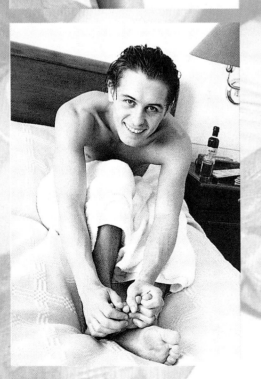

Along the corridor, a more fastidious person is already unpacked and has a neat line of shirts, suits and trousers hung up in the wardrobe. **Mark Owen's hotel room is sweet - really sweet.** On the radiator hang three pairs of underpants and a t-shirt which he has just washed in the bath. His three large suitcases lie open with the immaculately folded piles of clothes on display. The things he is most likely to wear are already hung up. There is a black bin liner sitting in the corner into which he has thrown his dirty washing. He's not going out tonight - he may have a game of pool with Rob but he wants to get an early night to shake off his cough which is still hanging around. On his bedside table there is a card and an envelope. The card is from his sister and says very simply: "To Mark, I love you and always will, love Tracey."

Like his main room, **his bathroom is immaculate.** There is a toiletry for every eventuality. "I use about one-tenth of what I bring away but I can't leave any of it behind because you never know what you might need." You are never, **ever**, going to need this many clothes, this much shampoo, this many aftershaves and no-one – but no-one – gets through this many pairs of underpants!

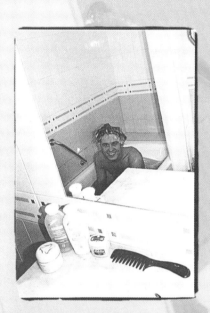

Right now, he's in the bath, this **most desirable of all pop idols,** lathering his mop of hair and piling it on top of his head while he washes his arms and chest. He's thin - all of Take That worry that he's too thin. His ribs are showing as he stretches across to reach the soap, but his legs belong to a footballer. He whistles with fake nonchalance, trying to act as if a writer and a photographer aren't recording his every move.

A few yards away there is an almighty racket occurring. Robbie has left his door open and has MTV on. He is jumping up and down on his bed, singing like mental.

He has only been in the room a few hours and already it looks as if a bomb has hit it. Most of the bedclothes are on the floor, every door to every wardrobe is flung open and there's a mixture of clean and dirty clothes scattered on every piece of furniture and on the floor. Some of his toiletries are loose in the bottom of his bag, without lids. But most of his toiletries are left behind in other hotel rooms. His mum has taken to buying him **bumper family packs** of everything in the hope that they'll be too big to overlook and leave. It hasn't worked. He trots down to Mark's room, bursts into his bathroom and demands to borrow one of everything. Mark frowns. "Alright, but I want them back, Rob. Rob? Do you hear me?" Rob is already back in his room with armfuls of Mark's stuff. He discovers his "button" and the window lightens to reveal the now orange sunset sinking beyond the great solid lake. He ignores the poetic bit though. **"Hm, I see there is ice to be trodden on,"** he says mischievously.

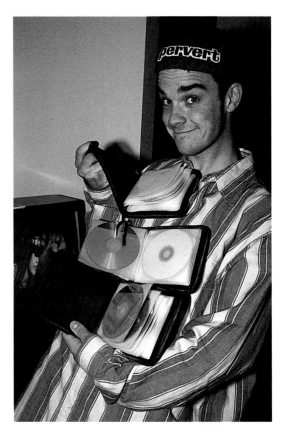

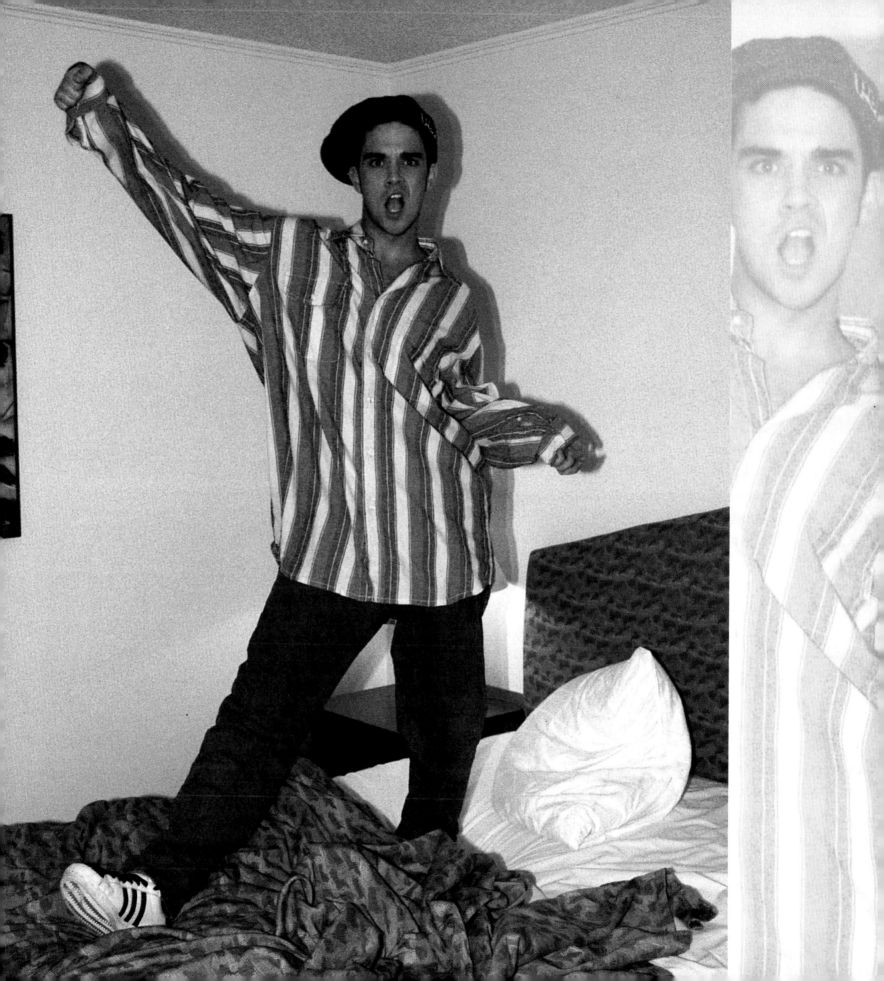

Howard is feeling better. He has picked delicately at a snack - "a really horrible toasted cheese sandwich from room service" and is now sitting contentedly at his keyboard which he takes everywhere with him. **"I'm trying to write some songs,"** he explains, "I'm way behind." He doesn't want us to take pictures of his room because it's so **untidy.** "People will think I'm a right slob!" he protests. He obviously hasn't visited Robbie's room lately. By comparison, Howard's room is not so bad. His clothes are laid across the bed and the chairs, and he has even managed to hang a few shirts up in the wardrobe. A greasy tray from room service, quietly collecting bacteria, sits on the desk next to his boots and socks. His manly bag of toiletry articles looks sadly depleted. "Rob's been borrowing me stuff and he never gives it back."

Unlike the other Take That members, Howard doesn't room hop that much. You will always find Rob's door open. He spends nearly all his time in the clean comfort of Mark's room where he will be pampered and mothered. During the British leg of this tour he thought his hotel room was haunted and slept with Mark all night. Oftentimes Gary will pop to Jason's for a chat, or vice versa, or they'll go out to eat together (they are united by their love of curry), but Howard is a very **private person.** His door is usually shut. Often he may only be watching TV but he'll be doing it on his own.

By now it is dark and **Jason's door is open.** The dim orange lamplight spills out of his room which isn't the quaintly organized little station it usually is. Normally, he'll have his black bag of tricks on the desk, open. His books - his cerebral work-out - will be on the desk and his clothes will be laid out ready to wear. He carries a little black zipper bag for his toilet things which he lays out ready for use in his bathroom - most of his toiletries are immaculately clean and there's always a few aftershaves to choose from, which he never uses. He eats breakfast in his room where he'll watch TV or read, or chat on the phone to his mates and his family. **Whatever gifts fans give him he takes to his room,** so there is always a bunch of flowers or a few cuddly toys on the sofa. He does his writing, his pop star duties, in his room so he is more often than not to be found sitting at the desk filling in questionnaires, signing

pictures or writing letters. But tonight is different. There are three portraits of him by fans propped on the back of the sofa - he's been lugging them around all week but apart from that his suitcases remain shut and the room is bare. He is in bed, naked, with the sheets pulled just across his lap. Paul the security man is dialling a number for him as Gary walks in, still not really sure if Jason is **ill** - he's done so much complaining about his arm, leg, whatever, that this has almost **got** to be a joke. It isn't. The doctor has been and has confirmed the worst - Jason has got a severe case of tonsillitis. There is a glass of water and a jar of antibiotics by the bed and just beside Jason's bare leg, an uneaten bowl of soup. He's looking very **sorry for himself.**

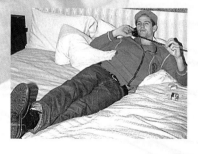

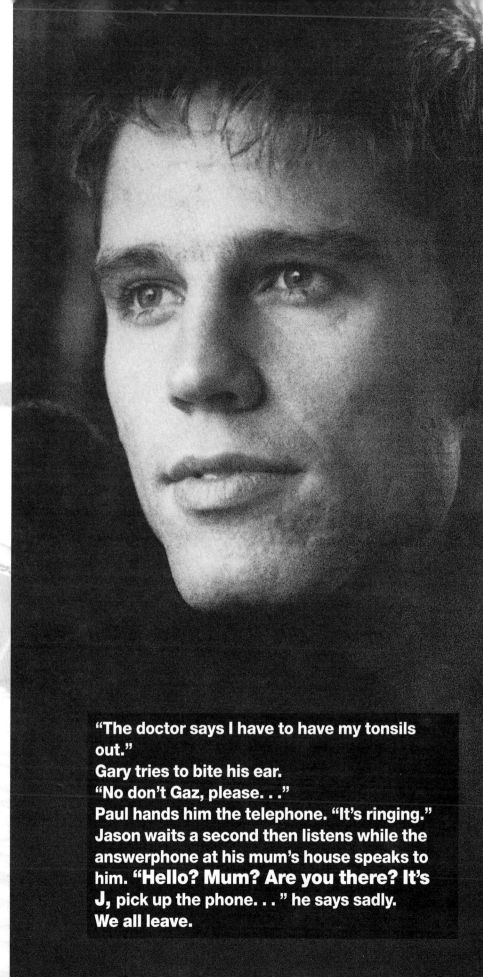

"The doctor says I have to have my tonsils out."
Gary tries to bite his ear.
"No don't Gaz, please. . ."
Paul hands him the telephone. "It's ringing."
Jason waits a second then listens while the answerphone at his mum's house speaks to him. "Hello? Mum? Are you there? It's J, pick up the phone. . . " he says sadly.
We all leave.

A cruel wind has blown in with the desolate night and is whipping round the almost empty hotel, adding to the prevailing spook factor. It feels very far from home. The group's spirits are flagging and Soozii is worried. "I feel like I should do something. I think I'll light the fire in my room and whoever's up can come in for a drink." She gets a roaring blaze going in the fireplace in the lounge of her large suite and phones Gary who has just returned from a chilly stroll along the lake shore. He doesn't hesitate – the words "warmth" "sandwiches" and "Bailey's" were mentioned and he is on his way.

The fire is crackling cosily, the mini bar is open and coffee and tea are on their way up. Eventually, the group arrive. They can never resist **the magnetic pull of a Take That gathering.** Lured by the comfort of the fire and laughter, they turn up, one by one. Howard is first. He wasn't asleep but he was in bed.

"What's going on? It's past midnight."

He takes a seat on the plush sofa and stares into the fire. Rob is next. He bumbles in with both his hands covering his portions – he is completely naked.

"What's happened? **Is it a party? Smart.** A fire! I'll go and put some clothes on."

Next is Jason who wasn't woken by the noise – it's a very quiet scene – but just knew that something was going down. He has a towel around his waist but he needn't have bothered – it keeps slipping and it's hiding nothing. He swallows a painful swallow.

"What's happening in here then?"

He is offered a drink and accepts some water. He sits by Howard and joins him in the mesmeric light of the fire. He sips his water and hunches over the flames, greedily soaking up the warmth. He's feeling a bit better but no less sorry for himself.

"Just think of the rubbish I've put in my body over the last few weeks – the injections, the ones in my ankle, the ones in my arse

– all the antibiotics. I've definitely learned my lesson now though. Next time, we have to prepare for a tour. And I'm not playing badminton, or having arm wrestles or playing football or staying up late going to discos and drinking red wine. No more. . . "

Mark's arrival interrupts this opus. He had gone to bed for the night and was sleeping soundly but, like Jason, he got the vibe and is now here, wearing underpants and a short t-shirt which he is vainly trying to pull down around his nether regions. He squashes next to Howard – a habit of his which normally irritates whoever the squashee is, but this time Howard smiles, makes room for Mark and puts his arm around him giving him a little hug. For the next few hours the group chat about their ailments, about this, the last leg of their tour and old times.

Jason smiles.**"This is beautiful sitting here like this all together isn't it?"** Everyone nods and contemplates how nice a moment this really is. Mark is the first to answer.

"Yeah, we should do this more often. It makes us feel like a family."

When the last of the coffee has been drunk, Take That drift off to bed as they came, one by one, each feeling that something important has happened and that, **in some small way, each one of them has been healed.**

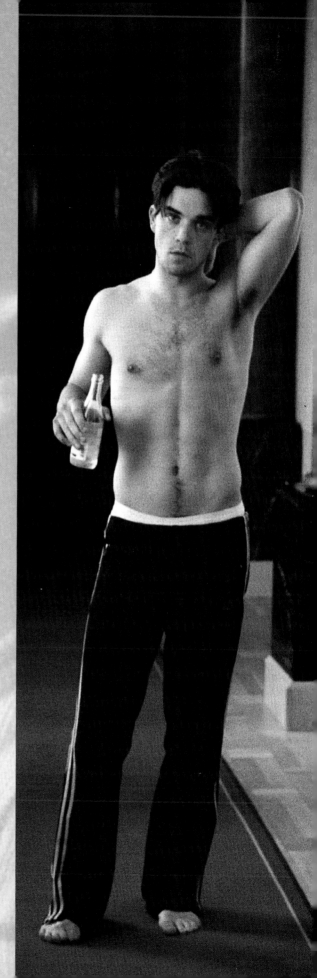

"Oh shiiiiitttte! Help me!!!!! I don't like this at all!"

Robbie Williams has managed to stand on the **only piece of unsecured ice on an otherwise immovable lake.**

Kevin, his assigned bodyguard, offers to carry him ashore.

"Oh no no, that's too embarrassing. No no. . . "

He hoists his trousers up and wades through the dangerous mush –

yesterday someone went through the ice and the ice sealed over and

. . . and that is what is on Rob's mind now. He chickens out and takes

up Kevin's offer. Once he is back to safety he joins Gary who is sitting

on a wooden bench drinking coffee on the verandah of the beautiful

lakeside café.

"Oh, I can't stand this any more!" says Gary lapping it up. "This is a

rotten life isn't it? I'm just so fed up!" He grins, settles back onto his

bench and sips at his coffee.

Just visible across the ice in the glare of the sun

is Howard, making a rather poignant tableau. He

sits on the ice writing, alone, in a world of his own.

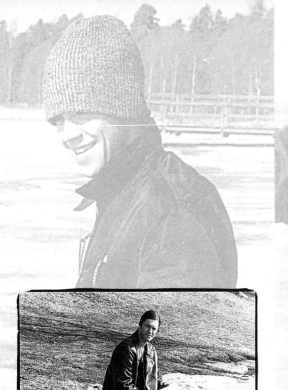

"Oh shiiiitttte! Help me!!!! I don't like this at all!"

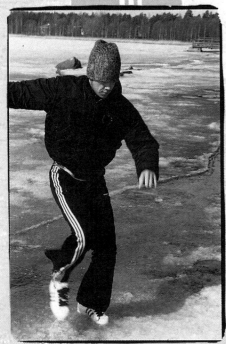

"I wasn't being unfriendly earlier on when you were all at the café and I was sitting on my own. I was trying to write. I don't want you to think I was being funny."

Howard Donald is a mystery. He's the member of Take That who reveals least about himself. He's genuinely shy and there isn't a pretentious bone in his body. He has, it would appear, been almost completely **untouched by his fast-moving, powerful and lucrative career.**

"God this is strange isn't it?" he ponders.

"I never thought we'd be this famous or that I would have money.

"I never thought we'd be this famous"

I remember in the early days I was walking down the street with Nigel, our manager, and I saw this car I liked. I said: 'Oh look at that car, Nigel.' And he said: 'You'll be able to buy one of those one day.' But I never really believed it."

Howard likes his hair. He only washes it once a week "to let the crap build up because it goes all fuzzy when it's just washed" and while we're on the subject you might as well know that he never uses soap on his armpits because he thinks it makes you sweat more. Jason is a big fan of Howard's sense of humour. "He's just so deadpan – he cracks me up." On the tour bus one day, Jason and Mark are discussing animal

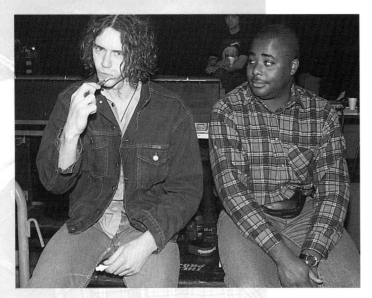 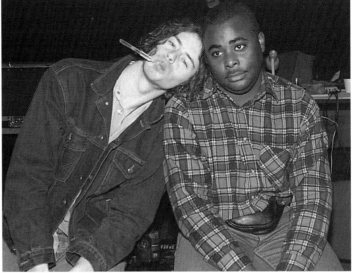

cruelty with regards to horse racing. Jason says that he thinks the horses enjoy the race and uses the example of the time when Desert Orchid strutted onto the track and reared up on his hind legs to show off his beauty to the crowd. Mark disagrees and says that using any

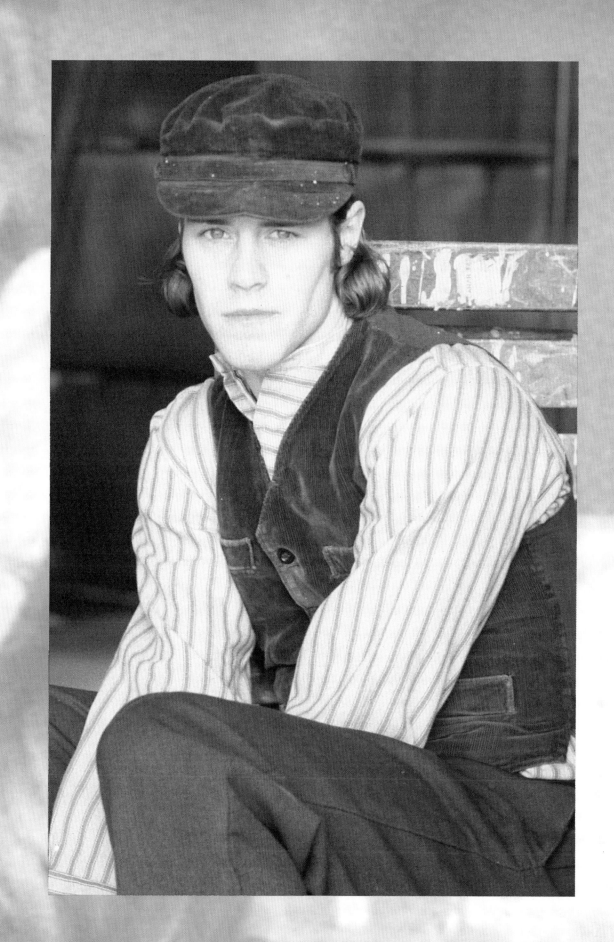

animal for sport is cruel. Howard hasn't said a word and then innocently says: "But it's OK to kill birds and cats though innit?" Of course he doesn't mean it, but it's enough to make Jason and Mark cry with laughter.

Human suffering of any sort profoundly upsets Howard. An early story from Nigel concerns a time when Take That went to a hospice to visit patients who were dying from AIDS-related diseases.

"Howard was introduced to a gay man who was thin and dying from AIDS and he just put his arms round him and burst into tears. I was deeply touched by it." Bearing this in mind you can believe the sort of things that go through Howard's mind sometimes when he is on stage. "Tonight, I don't know why I started thinking it, but I was on the stage and I wondered if any of the girls out there had lost their parents. I know it's a strange thing to think but they all had such sad faces and I wondered how they would cope being without their parents at such a young age. It made me really sad. Maybe it's because I think about it all the time. I'm so worried about being without my mum and dad."

This sometime preoccupation with death also spills over into Howard's "hobbies". He is fascinated by anything gruesome.

"Look, I'm not sick! I don't watch Vietnam videos for kicks you know, it does genuinely upset me. But it also fascinates me." This morbid fascination runs into books, videos and films about various subjects of gore. His latest acquisition is a set of three videos called *The Faces of Death.*

"It's all the stuff they can't put on the news. It's very upsetting, especially the animal bits – it's enough to make you vegetarian. I had to watch it in stages at first but I'm. . . what's the word. . . curious."

Last night tonight. It means relief, sadness, and a lot of fun. Jason, who has been desperate to get back to England and his own physiotherapist, is already nostalgic.

"Last night, guys," he says to the dressing room in general.

"The last time we do the rock 'n' roll section, or the old time medley or 'Pray' in the cloaks..." says Mark glumly.

"The last time I wear my dress," laments Jason.

"It's not as if we've not got anything else coming up though is it?" says Gary trying to cheer up everyone.

Howard sniffs a bunch of roses from a fan.

"Smell that. Smells like a rabbit hutch dunnit?" he says to Mark who agrees. "Definitely a rabbit

hutch." Rob walks in. "Rob, smell them, what does that smell of?" Rob sniffs and says matter-of-factly, "A Rabbit hutch."

Gary delves into the box of chocolates that catering have given them as a goodbye present and then opens a gift from the meet 'n' greet they've just done.

"This is great. Look at this. The only present I got tonight. This girl gave it me and look."

He holds up a set of hand and wrist weights and reads the accompanying note.

" 'Get yourself fit.' Thanks love. There's gratitude for you."

Howard giggles at another reference to Gary's anti-hero status and adds, "I'm half and half, me. I'm looking forward to getting home but **I get upset saying goodbye to everyone.** You never know what the future holds. I know we'll most definitely do a world tour next year but you never know. . . You make good friends and you don't know if you'll ever be working with them again."

In catering the musicians are arguing over their evening meal. They haven't decided yet which end of tour pranks they should play on Take That. Lou is sadly packing cereal boxes and soya milk into large trunks.

"I'm really sad this tour is over. It's been bloody hard work but Take That are just brilliant guys."

Gary is on the phone in the production office, talking house with his dad. "No, dad, dad, don't turn the heating off, leave it on, it costs a fortune to heat it from scratch. No, the switch is by – look put Marge on the phone will you? Marge? Are you alright? Good. Don't let him turn the bloody heating off. I'll never get the place warm again and I'm coming home soon. All right. OK Marge, bye bye."

From the first yell of "What's up Helsinki?!!!" to the last goodbye wave, the concert tonight is a scream. There can only be four thousand people here – quite a turn-out for Finland but it is the sort of concert that the group's British fans would treasure – a real insight into personalities rather than personas.

Robbie is making the most of his last chance to show off on stage. He wears a sad pork pie hat that has been thrown on stage, picks up a teddy bear, has a punch up with it and tosses it back into the audience, drops his trousers and does his famed Norman Wisdom impression (which doesn't mean much to the Finnish crowd but they giggle anyway). Every instrument they pick up has a pair of knickers or a toy or a bra stuck to it. Howard's mic is turned off during his solo and, best of all, when Take That pretend to gun down their musicians in 'Whatever You Do To Me', this time the musos are prepared, pull out toy guns of their own and shoot back. Take That are flummoxed, they look to each other desperately trying to communicate telepathically. In the end they shrug, ad lib, fluff their lines and snigger their way through the scene. When Robbie introduces his backing singers during the rock 'n' roll section, he introduces them as Pink Floyd instead of The Beans Boys. Mark's Elvis impersonation is wrecked. His guitar solo is played completely out of key while a crew man pokes a huge teddy through the curtains and makes it dance up and down. Mark has no idea why the

entire audience is in fits. He turns, sees the massive bear and does the only thing he can do – dances with it. At the end of 'Relight My Fire' Jason, filled with emotion and gratitude, comes over a bit rock 'n' roll and screams, **"Helsinki! I don't need this shirt anymore!"** He takes off his clothes and throws them to the audience. The others think this is a good idea - Howard takes off his skirt, Robbie his vest, and so on. 'Pray' is a scream. Instead of just five people in monks' habits on the stage there are nine or ten – crew members having a laugh.

As the five correct monks throw off their cloaks, the crowd go absolutely mental. It seems all the tension of the last few days, the exhaustion, the internal wranglings, the ill health is forgotten as **Take That give it their all.**

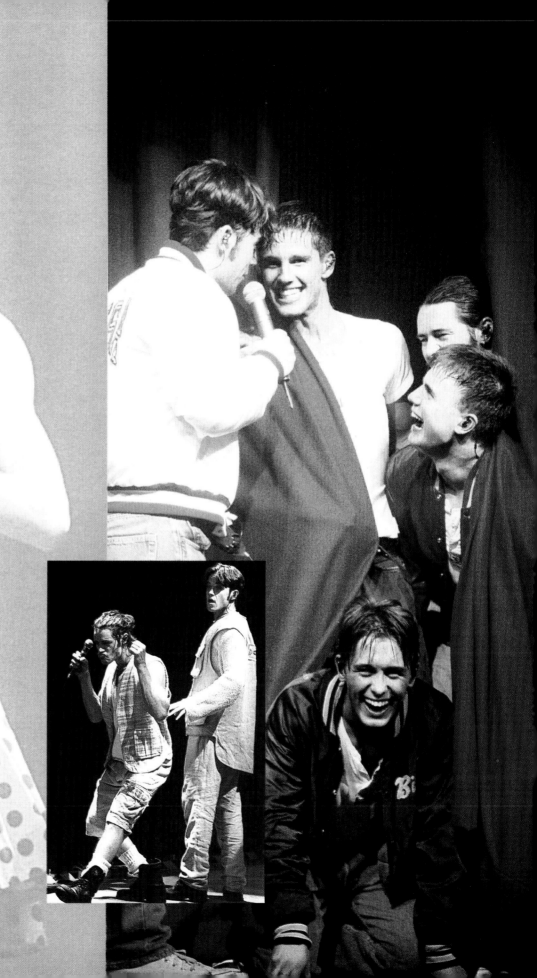

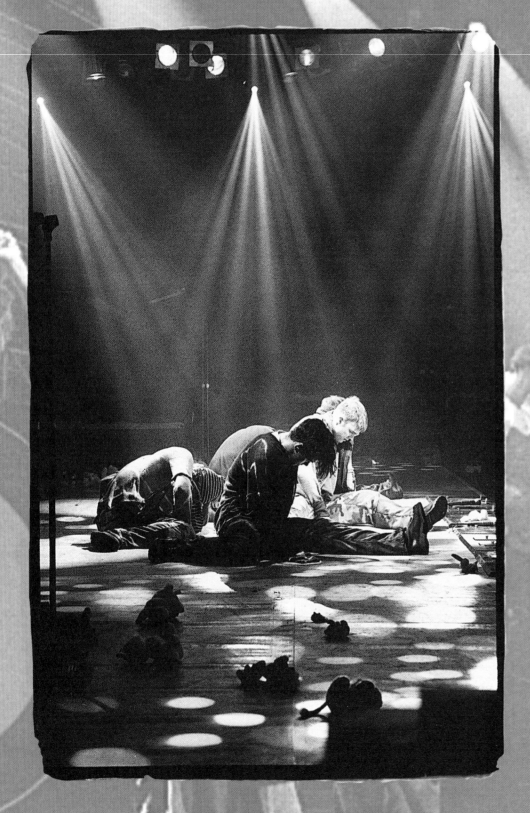

The crowd join in, Soozii, Ying and co fight back the tears and well, it's all a bit moving really. Backstage, Robbie, Jason, Mark, Howard and Gary put their robes on for one last time. Gary looks at his watch, looks at his mates and says, "Right, let's knock off, clock off and sod off!"

That's it. The tour is over. By midnight, the crew are dismantling the stage one last time. A solitary fan wanders along the dark deserted street. The wind whacks discarded banners and forgotten programmes round her ankles. She cries, "Robbie! Robbie. . . " but she knows that Robbie is gone.

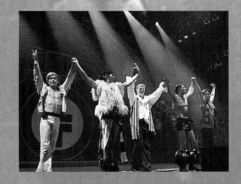

The last interview of the Everything Changes tour takes place back at the hotel. It is for Lister TV, the national Finnish station, one bloke with a goatee beard and a camcorder from the Ark. The Finnish record company are here, too. They have a handful of gold discs to present to TT and they watch now with baited breath.

The group has taken their country by storm and they've never seen them in action before. Robbie realizes there is no way the TV bloke can manage to do everything on his own so he offers to be the interviewer. He faces his TT colleagues, tongue firmly in cheek, satire to the fore and conducts an interview for which British TV executives would sell their mothers.

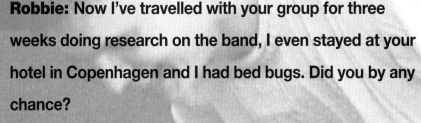

Robbie: Now I've travelled with your group for three weeks doing research on the band, I even stayed at your hotel in Copenhagen and I had bed bugs. Did you by any chance?

Jason: I pulled the bed out and a huge bug pulled it back again.

Rob: (With disdain.) It's Jason Orange isn't it? Isn't that a fruit too? Do you get the micky taken out of your name? Jason giggles.

Rob: And I believe your name is Mark Owen and people say to you, "How much am I owen you?"

You get the picture. The TV bloke goes home knowing he has the most unique interview anyone has managed to get with the hottest property in Europe. He's happy and the room is weeping tears of laughter.

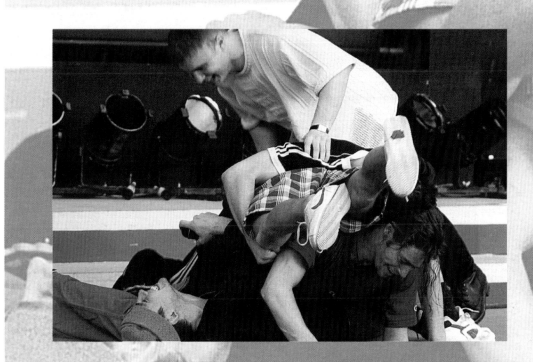

"There's no **time** for *time off* after this tour. As soon as we get back we've got to make a video for

Love Ain't here Anymore.

Between now and then seems like a **lifetime...**"

ard

How do the fans know that Take That are going to this particular curry house? It's supposed to be a secret but a small group of erstwhile TT lovers are one step ahead of security tonight.

Take That hover by the bus doors.

James holds up a prohibitive hand. "Stay on the bus, we can't get off."

Mark pushes his way to the front. "Oh yes we can. Come on, there's only about thirty of them, we can handle it."

He is right. Being Finnish fans and terribly shy and polite, the girls move to one side and allow the group to enter the empty restaurant. **This is the end of tour party and TT are celebrating the way they know best – with a good curry!** Once inside there is a table fiasco. Take That want everyone to sit together on one big love table. Jason and Gary take matters into their own hands and start to move furniture while a waiter panics.

The starters arrive. Jason greedily hogs the mango chutney and poppadoms while Howard dips into the yoghurt raita.

Howard: Here J have some of this.

Jason: I'm not eating that crap.

Howard: It's yoghurt. A few months ago you told me it was good for you. I'm not taking your advice on diet any more, you change your mind too bloody quickly.

Gary: Eh, lads, I'll soon be there, in my house, in Barlow's abode – listen when we get to London I'm going to Harvey Nichols to look for a bed. . .

Everyone turns away and takes up conversation with someone else. Gary laughs.

Gary: It's like that scene in Airplane. I start talking and people set themselves alight with boredom!

Everyone orders - Mark and Howard have veggie kormas, Gary his chicken korma, Jason a vegetable madras and Rob a manly meat madras. They order drinks. Beer for Mark, Rob and Howard, a girly shandy for Gary and an even girlier mineral water for Jason.

Howard: Are you not drinking tonight Jason?

Jason: No, I'm taking antibiotics.

Howard: Wheyhey! Drink some beer, lad, and don't be a poof!

Jason: Well, maybe I'll have a glass of red wine. . .

Howard: Don't be such a ponce. Get some lager in yer!

Jason: I've been a miserable sod haven't I?

Gary: You've been bloody horrible Lander.

Jason: Oh I haven't been that bad have I? Well, I suppose I have been miserable. It all started with my arm. . .

Everyone: Oh shut up!!

Outside the group of fans has swelled to about a hundred. They all have their noses pressed up against the window which they are banging on while yelling the name of their favourite TT.

"You can't even have your **dinner** *in* **peace!"**

Howard

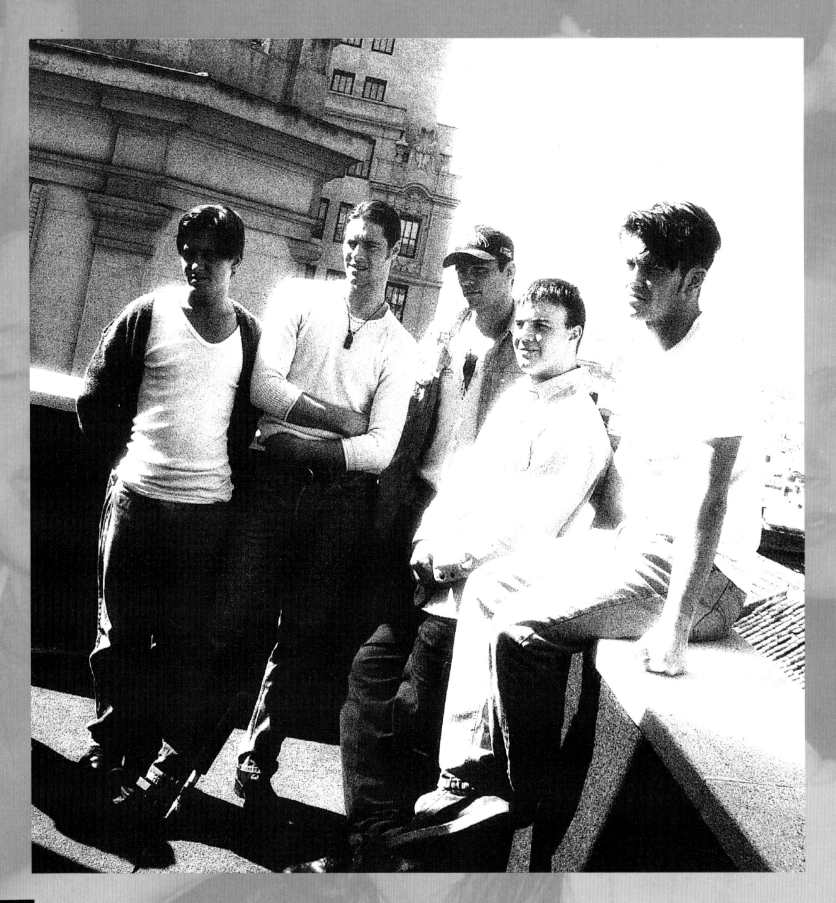

Gary: Oh they've got cameras. They can't get a picture of me looking like this! He has his ears prised into two napkin rings (one of his many party pieces).

Howard: Yeah, fans keep taking pictures of me mum's hall through the letterbox and it sets the alarm off.

Gary: You see, you don't think about all these things. There was this one night when I was lying in bed and I could hear (puts on broad Manchester accent), "Gar-eh! Gar-eh!" And I thought, Christ, they're in the house! Where are they? So I put me pipe out (laughs from everyone) put on me dressing gown and slippers (more laughs) and went searching. I couldn't find anyone but I kept hearing, "Gar-eh! Gar-eh!" and it turned out this girl had her face pressed right up against my bedroom window calling me. And do you know what she wanted? She wanted to know if I was going to come to her three-year-old brother's birthday party the following day.

Mark howls with laughter. Howard is deadpan.

Howard: Did you go then?

Gary: Did I 'eck.

And finally the discussion turns, inevitably, to the subject of homosexuality.

Jason: I bet the newspapers think it would be the biggest scoop if one of us was really gay!

Howard: Yeah. . . it's a shame we're not really.

Robbie: No, but it would be a good news story.

Howard: Or if we had steady girlfriends!

Jason: I was looking for a bed once in Manchester and I met this mate of mine and she asked what I was doing and I said I was looking for a bed and she said she knew where they had some lovely beds. Well, you can't say to a mate, I can't be seen with you just because you're female, can you? So there we were, looking in the window of a bed shop and along came Nigel! He walked straight past and said, "Hello I'm the photographer from the Evening News!"

Robbie: Hey, maybe when our popularity dies down we can say one of us is gay just to get the interest back up!

Gary: I'm not saying I'm gay.

Howard: I'll say I am!

Jason: I'll kiss you Howard! We'll have a picture of us kissing and people will think we're having an affair! I love it that loads of people think we're gay! I spent the first few years of our career not denying it just to get people going! It really used to amuse me.

" Imagine all the

worst places **to get**

caught in!

Mothercare!

A *wedding dress*

shop! "

Gary

Gary: If there was a gay member of this band he would have had a nervous breakdown and left by now!

Howard: Are you going to Harvey Nichols tomorrow then or what, Gaz? 'Cause if you are can you get me some scented candles?

Gary: Oh, now that he wants something he's interested. Come with me Howard.

Howard: No, I'm not that interested.

There may be *niggles and moods,* **illness and injuries, but** Take That **are in** **this** **together.**

Gary pays for the meal with the group credit card (he's in charge of it). While they wait for the security chaps to make a path through the fans outside, Mark and Jason stand in a corner chatting. Without realizing they initiate an endearing ritual which has been with TT since the group first formed and the five cemented their friendship. They have one of their now-infamous touching sessions. It's purely heterosexual, in case you're wondering. Jason strokes Mark's hair and neck while Mark rubs Jason's back. They do this quite absent-mindedly while looking out of the window. Gary joins in, crushing them in an almighty hug and flicking their earlobes. Rob points to the six cans of lager he has stowed in all his pockets. **"I'm partying tonight!"** Then he sees what's going on in the corner and wanders over quietly, cans clanking as he goes. He allows his friends to hug him and kiss his cheeks. Only Howard stands alone. Gary spots him and plants a huge, soggy kiss on his cheek. Howard squirms, "Urgh! Gerrof." The others follow and Howard can't fight them all. "Stop it! You're tickling me!" He covers his head with his hands and succumbs to wet kisses and ear biting.

Each member of Take That is on tour with his four best friends, personal nursemaids and harshest critics. No matter what happens there's no chance of any real danger when you're locked in a safety vacuum this strong. If it was at all possible,

it would seem that Take That have grown even closer on this tour and they know they will miss this closeness when the tour is over. It's almost as if they need to reassure one another that they are all still here, still friends and still sane.

Howard: Tonight on stage I was upset because it was the last night and I thought, what if this was our last gig ever. I don't think I could cope.

Gary: Oh we've got plenty more gigs yet Howard.

Howard: I know, but it worries me. I worry if we'll still be friends when it all stops.

Gary: I think we'll always be friends.

Howard: I mean, we never fight. . .

Mark: We've never even had a proper argument have we?

Howard: No, it's good that.

Howard: (Mischievously.) I do worry that when the band is over Gaz won't bother with me any more.

Gary: Well, I'll probably be busy with Elton and George and the other serious singer/songwriters. . .

Howard: It's true, though. He doesn't even phone me any more.

Gary: Hang on. I came round your house.

Howard: Only to pick up your things.

Gary: Oh right. That's lovely, that.

Hotel Kalastajatorppa: 6.15am. It's time to go home.

After the curry experience Take That partied the night away with the crew. Some of them have had only two hours sleep. Some have had none. The sun is slowly rising, turning the hotel corridor bright orange. Mark waddles along it. "Oh, I'm not feeling too good and no one's listening to a word I'm saying because I'm talking rubbish. Where's Bob?"

Thirty seconds later Rob staggers by in the same direction, his gaunt face and wide-eyed stare sit beneath a slightly askew Stussy hat. "Oh, I feel like shit. As soon as that plane moves today I'm going to be sick. I need to find Mark."

Howard can't get up. He lies in bed, deathly still. Jason is leaning over his sink, staring into the mirror, immobile. Gary is sitting on the end of his bed with one leg in his trousers.

"I'm feeling a bit weak," he mutters, "but I'm sure I'll perk up. Once I'm in Harvey Nichols. . . "

The whole of gate A3 at Helsinki airport has been Thatted. Everyone is here, crew, caterers, production team.

Only Howard is missing. He has chosen to fly home to Manchester before joining the group in London for Top Of The Pops.

Robbie watches his hand luggage being scanned, collects it, turns to his sorry-looking mates and holds his hand in the air teacher-like. "OK everyone. I've had yards of Pro-Plus and I'm feeling great! All follow me! Let's find where we're all going to sit! We'll get a camp vibe going and anyone who wants to go to the duty free or for a wee can go from there!" He marches ahead purposefully and loses steam about three steps on. "Er. . . what are we doing?"

They find two rows of seats opposite one another and park themselves among their piles of

bags and jackets. Through the windows it's another crisp, cold, steely blue morning. Inside, Take That doze. Jason coughs weakly. Rob is too tired to feel sick any more and has fallen into a pleasant stupor with his head on a catatonic Gary's shoulder where he dribbles quietly.

Mark, however, hyperactive as usual, is up and about. He searches through his pockets for some money. "Do you think that woman at the coffee bar will accept Visa?"

Gary looks up at him sleepily. "God, you're stupid Owen. Visa? For what? A coffee? Here's some money - and don't spend it all at once, lad."

"Yes, dad."

Mark wanders over to the café. He sorts through some unappetizing pastries, finally settling on the biggest. He picks it up and sniffs it. "Yes, that seems good and sugary enough. Now, I'm trying to stay off the coffee but this is definitely a coffee sort of morning."

He sees that you have to get a paper cup and pour your own coffee from the machine. He's not mentally equipped for such tasks today. "Oh, this is going to complicate matters isn't it?"

He knocks over four very tall columns of paper cups. He scuttles after them apologizing profusely to the non-smiling woman behind the counter.

She has no idea who he is and she doesn't care. He's ruined her display and he better put it right again.

Mark: I wonder what the reception will be like in England.

Rob: Do you think there will be a backlash? We're in everyone's faces so much now.

Mark: Do you think we're still **famous.** I mean, we've been away so much. . .

The flight to London is called and Take That board the plane home.

London Heathrow. Take That stand around the luggage carousel waiting for their suitcases. Jason heaves a sigh of relief.

"I know our home is Manchester but London feels as good as home right now."

A genial Ealing comedy-type bobby approaches James. They know each other well and plan Take That's exit. "There are a lot of girls here today, sir. I would advise the side exit."

At the side exit, three black limos with darkened glass windows wait with their engines running.

The suitcases come through and Mark piles bag after bag onto his already teetering trolley.

"Look at Owen's trolley!" says Gary. "He brings so many clothes with him! Look at all his bags! Mind you, he does always look good doesn't he. You have to hand it to him."

Mark hears this. "The reason I've got so much luggage is because I bring clothes for **Gary** because **Gary** thinks you can go on tour with three tracksuits and an anorak."

The group wheel their way towards customs. Depending on the whim of the customs officer this can mean a clear passage or hours spent having your smalls turfed from your case in search of illegal substances. "I hope we don't have any trouble today," groans Mark as he passes through the green channel. He isn't stopped.

"Wait, don't go yet." This is Gary. He, Jason and Rob are deliberately lagging behind.

"This is a secret. We send little Marky out there first and the girls all crowd round him and we slip by unnoticed! He hasn't caught on yet that he's the decoy!"

Mark doesn't mind. He's pleased to see the familiar British fans. It takes some time before he can be dragged away.

Finally Take That speed off leaving Europe, for now, safely behind them but knowing they'll always be welcomed back. It may have been the tour from hell but it was worth it.

Take That needn't have worried about whether Britain still loved them. On their return they performed on BBC's *Live And Kicking*. This memo was sent to all BBC personnel in anticipation of the event

TAKE THAT VISIT
The band Take That will be visiting the site to participate in the last episode of the present series of *Live And Kicking* this Saturday. On their last two visits, the site was besieged by more than 1000 fans. If there is a similar response on the occasion, the main gate will probably have to be closed for the duration of their stay. If this is the case all vehicles will be directed to the most suitable alternative gate.
Also, in the interest of security and safety, families and guests of staff and club members will NOT be authorized to enter Television Centre between 06.00hrs and 13.00hrs.

Tim Suter
Directorate Secretary Network Television.

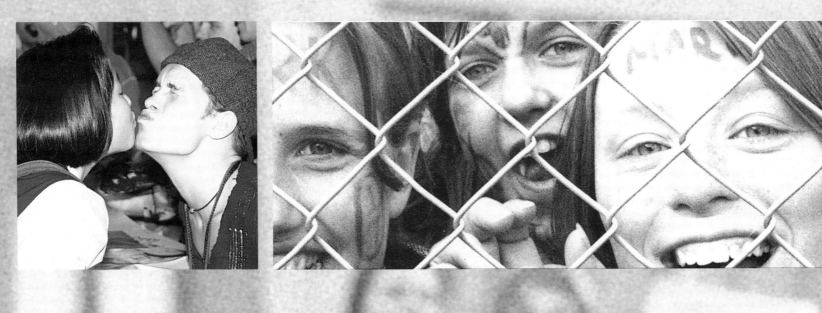

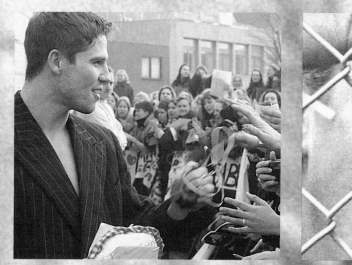
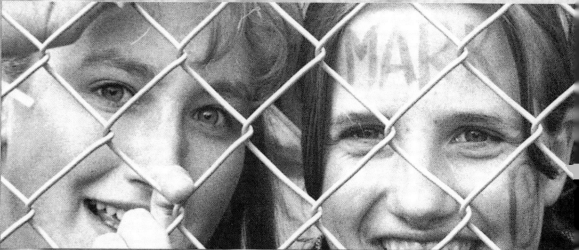

Three thousand fans turned up that day.

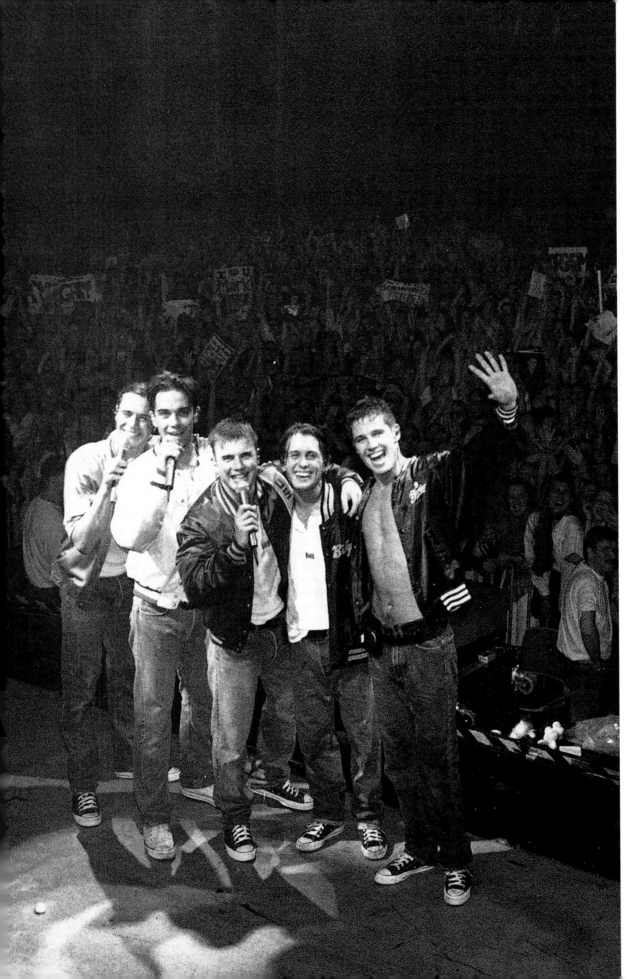

A special thank you to:

Soozii, Ying, James, Paul, Barry, Gus, Jenny, Skippy and the crew, Sean and Lou, Phil, Carolyn and Mal at Virgin. Sheila, Christalla and Maria Kadis, Louise Kent, The TT Mums, Tim Suter at the BBC, Simon Kenton and everyone at Idols, Philip's Mum and above all to Howard, Mark, Gary, Jason, Rob and Nigel Martin-Smith for making it all possible.

We thank you all.

Alex Kadis
Philip Ollerenshaw

Available on video:

Take That & Party,
Take That Live at Wembley,
Everything Changes,

and forthcoming release
Berlin
on 31st October 1994